SOUTH SHIELDS
in the 1950s

Ten Years that Changed a Town

SOUTH SHIELDS
in the 1950s

Ten Years that Changed a Town

E<small>ILEEN</small> B<small>URNETT</small>

AMBERLEY

First published 2016

Amberley Publishing
The Hill, Stroud
Gloucestershire, GL5 4EP

www.amberley-books.com

British Library Cataloguing in Publication Data.
A catalogue record for this book is available from the British Library.

ISBN 978 1 4456 5182 8 (print)
ISBN 978 1 4456 5183 5 (ebook)

Typesetting and Origination by Amberley Publishing.
Printed in the UK.

Contents

Introduction

South Shields changed dramatically in the 1950s. The marketplace had been all but destroyed by enemy bombing on 2 October 1941, as had much of the surrounding area such as the market end of King Street, Union Ally and Thrift Street. On 24 July 1940 the first bombs were dropped on the town and bombing continued until 24 May 1943.

Rationing was still in force on many of our essential food items, with bread and potatoes being added after the end of the war and in 1950 the meat ration was cut to 3 ounces (approximately 100 grams) per week. On the 19 May 1950 rationing on items like dried fruit and chocolate biscuits had been lifted. On 4 July 1954 rationing ended, much to the relief of the nation. Those people who were lucky enough to have had gardens or allotments had been encouraged to grow vegetables instead of flowers to help subsidise food supplies.

1950 was also the centenary of South Shields being granted its Charter of Incorporation and many celebrations were planned. Housing and rehousing was one of the pressing issues for men returning from the war – they often found their homes had been destroyed. Overcrowding was a big problem and unemployment another issue, although many men were re-employed in the mines and shipyards of the town.

Born just after the end of the Second World War, I can still remember what it was like to walk around parts of the town in the 1950s. The prefabs replaced many of the houses in the town destroyed in the 1940s and those the council had demolished, especially on what is now the Woodbine Estate.

On 1 August 1948 the government introduced the National Health Service, which improved the health of the nation. In 1950 both the vaccines for whooping cough and tuberculosis were introduced and in 1956 inactivated polio vaccinations (oral) began in the United Kingdom, and the smallpox vaccine one year later.

James Chuter Ede was our local MP; Clement Attlee was the Prime Minister at the time and it was during this government that we had the Festival of Britain in 1951, with commemorative silver crowns being minted. The Latin inscription around the edge read '1851 By the industry of its people the state flourishes 1951'.

During the 1950s Britain lost a few more countries from its empire. Its world domination started to wane but because of the atomic age it still held a high place in

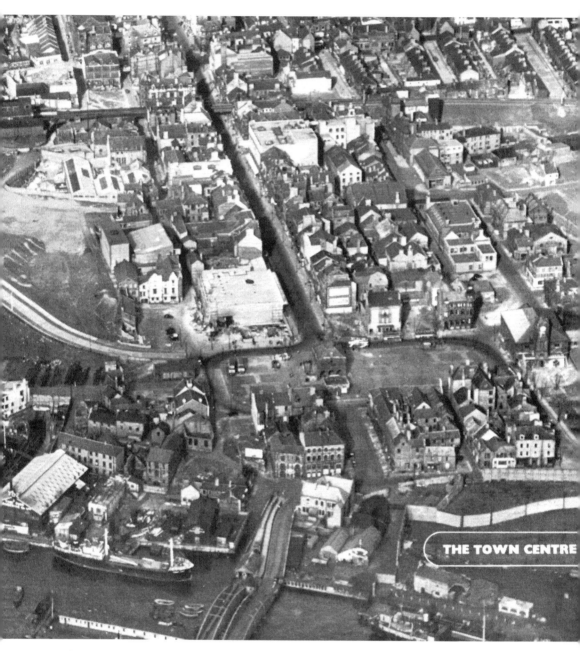

THE TOWN CENTRE

This is what was left of the town centre in 1950, swaths of which had been destroyed by enemy bombing on 2 October 1941.

the world. The Cold War and the nuclear threat gave rise to the campaign for nuclear disarmament. National Service was still in force for all healthy men over eighteen years old, except those in one of three essential services – coal mining, farming and the merchant navy. These men were likely to be called up for service in one of the armed forces for a period of eighteen months. Due to the involvement in the Korean War, in October 1950, the service period was increased to two years. The increase in the TA, which had been reformed in April 1947, saw the building of Frenchman's Fort Territorial Camp on Highfield Road. However, even with the world being such a turbulent place, on 21 February 1952, it was deemed that identity cards need no longer be carried and on 22 May 1952 the National Registration Act of 1939 was repealed. Britain, on 3 October 1952, managed to become the third country to test an independently developed nuclear weapon. This took place off the uninhabited Montebello Islands, off the north-west coast of Australia. Five years later on 15 May 1957 Britain's first hydrogen bomb was tested at Malden Island during Operation Grapple.

The 1950s marked the end of an era for many parts of South Shields. The sense of community and togetherness was sometimes lost in the march towards modernisation of everyday life. Most people still used public transport to travel to work and make recreational trips to the parks and the seaside – others walked. Some children would play in the street, many of which still had gaslight even though electric street lighting was introduced into the marketplace and Dean Street on 17 August 1896.

After the war modern domestic appliances that had been virtually unobtainable during the war, such as transistor radios, vacuum cleaners, electric fires, electric stoves, toasters and electric kettles, made for a revolutionary kitchen for the modern housewife, saving hours of work. Hire purchase schemes allowed for the modern housewife to 'buy now pay later' through instalments, making more expensive goods such as washing machines, refrigerators and televisions within reach. Demands for housing and other developments began to reshape South Shields, with new roads and purpose-built flats being introduced for the first time on new housing estates.

Men returning from the war resulted in what was known as the 'baby boom' and the town was expanding rapidly. Taste in music was beginning to change: vocal-driven pop was to replace the big band and the 1940s-style crooners vied with the new generation of singers. It was also the era that the teenagers began to find their feet. With more spending power than ever before, leisure activities such as music and films were focused on this generation and included artists like Lonnie Donegan, who started the skiffle music craze in 1953, then Bill Haley and His Comets with 'Rock around the Clock' hit Britain in 1955. The rock 'n' roll era had arrived in style.

Saville Bros' covers were blue. This one is from their King Street shop, of Jerry Lee Lewis's single 'Great Balls of Fire', released in 1957. (Photograph courtesy of Pauline Shawyer)

I

Centenary Celebrations

The year 1950 was the centenary of South Shields being granted its Charter of Incorporation as a borough. 1950 got off to a good start: a centenary book published by the council was sold, price 3s 6d, by the South Shields branch of the National Federation of Retail Newsagents, Booksellers and Stationers without profit as a contribution to the centenary celebrations. After much planning and preparation, many invitations being sent out and acceptances received, South Shields had a full programme of events that were to last until 1 July, and ending with the presentation of the new civic mace on 9 November 1950.

South Shields Amateur Rowing Club began the town celebrations with the Centenary Regatta on 1 July taking place off the South Pier at 2.30 p.m. Crowds gathered on the south pier and the beaches to cheer and watch both local and neighbouring clubs compete. Cllr W. A. McNulty, captain of the South Shields rowing club, introduced Mrs R. Bainbridge, the mayoress, who opened the event. Spectators were delighted with the thrills.

Results:-
Centenary Challenge Cup, W. M. Sherrington, Tynemouth beat C. Ritzema, South Shields.
F. J. McNulty Memorial Challenge Cup, won by Tynemouth A.
S. Powell Challenge Trophy, 1st Durham Amateur Rowing Club, 2nd Berwick Amateur Rowing Club.
Sea Cadets Whaler Race, 1st Newcastle Training Ship (Nelson Unit), 2nd Newcastle Training Ship (Rodney Unit).

For the first time Trinity Towers, the Marine School radar station in the North Marine Park, was open for Marine School staff to publicly demonstrate radar. Images of the harbour were reflected on a screen for visitors to see. Staff manned and operated the equipment, admission was free to visitors between 2.00 p.m. and 8.00 p.m. and only children accompanied by an adult were allowed admittance.

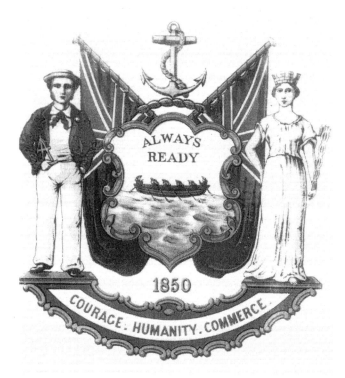

The South Shields coat of arms supports a South Shield's sailor, representing courage and the figure of commerce. The motto 'Always Ready' is above the lifeboat and 'Courage, Humanity, Commerce' below the scroll.

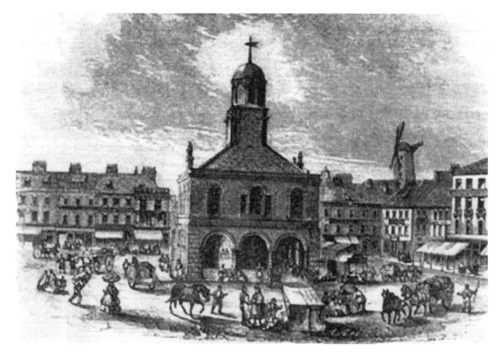

The marketplace in 1850 looking east towards Commerce Street, now Thrift Street. In the right-hand corner is the Rose & Crown, Commercial Hotel; it was also the excise office and post house, with Harding's Hill windmill behind.

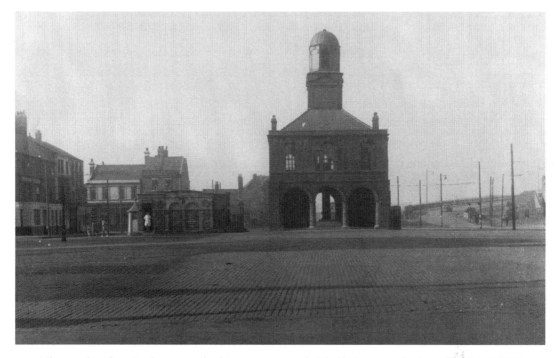

The marketplace in the 1950s looking east towards Thrift Street and where Harding's Hill once stood. Market Hotel, middle left, with the Norfolk & Suffolk public house, with white tiles, is two doors away and the Exchange Vaults in the corner. J. D. Ainsley's store is behind the public conveniences.

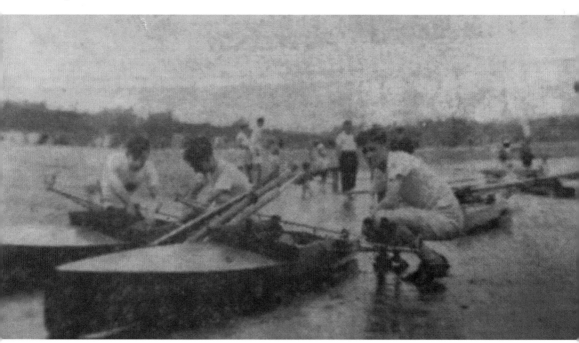

Rowing Club members getting ready for the first race of the Regatta.

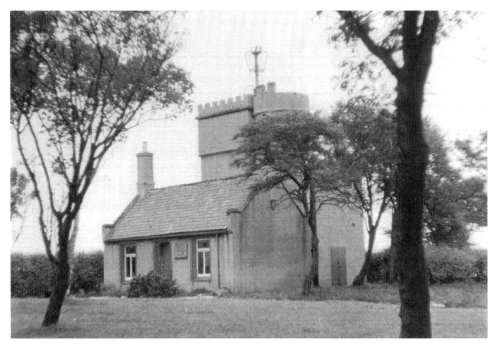

Trinity Towers, North Marine Park. Radar equipment used to train Marine Collage students was shown to visitors. (Photograph courtesy of South Shields Library)

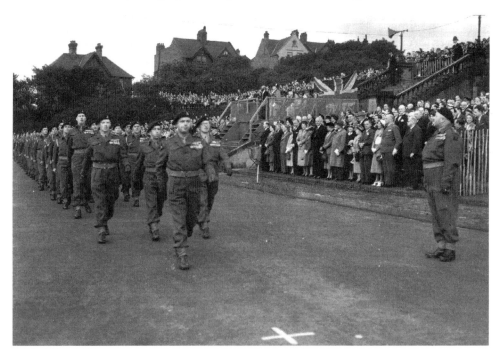

The Mayor Cllr R. Bainbridge reviewing a parade of the 274th Field Regiment RA (TA) after being presented with Freedom of the Borough casket and scroll. Lt-Col J. W. Grant Commanding Officer is to the right. (Photograph courtesy of South Shields Library)

Towards the end the day, both young and old made their way to the South Marine Park for the first major event of the Centenary Celebrations. The 274th Field Regiment Royal Artillery (TA) were presented with the Freedom of the Borough at a presentation ceremony in the Park at 4.30 p.m. 'in appreciation of the distinguished record of the regiment, with its long and close association with the borough'. The Regimental Band played music from 4.00 p.m. – a march past with the firing of a salute.

From Sunday 2 July to Sunday 9 July the Volunteer Life Brigade House on the South Pier was open to the public for those wishing to see inside the incredible building. On Wednesday evening at 7.00 p.m. an exhibition of special lifesaving drills took place at the South Pier by the Volunteer Life Brigade. As a comic climax to the exhibition they rescued men and a bearded captain. Armed with a birdcage and a keg of rum, they were brought ashore from a wrecked ship, carried out with efficiency and speed from the time a rocket with line attached was fired to the 'wreck' to the time the three 'victims' were brought ashore by the breeches buoy.

On Friday 7 July, 4,500 schoolchildren from all the schools in the town held a mass open-air concert at the Greyhound Stadium, Horsley Hill Road, at 7.00 p.m. with select items by Harton Colliery Band.

An International Exhibition of Pictorial Photography was held at the Public Library from Saturday 8 July to Saturday 29 July, which was opened by the mayor and was well attended over the course of the exhibition.

On Sunday 9 July, the British Legion Floral Cenotaph Memorial Service took place in the South Marine Park at 3.15 p.m. People from Northumberland and all parts of Durham came to the service. Members of the British Legion came from Sunderland, Birtley, Tow Law and Jarrow, bringing with them their own standards. Members of the public from all over the country as well as members of all the armed forces and the British Legion join together to remember the dead of two world wars at the service in the park.

On Wednesday 12 July and Thursday 13 July at 7.00 p.m. Westoe Cricket Ground in Wood Terrace hosted a display of physical training and folk dancing. The physical training display was given by more than 2,000 girls and boys. The junior boys and girls came on to loud applause. The senior boys and girls also showed off their physical training skills with excellent prowess and gymnastic equipment. The senior girls, wearing skirts and thin blouses, carried on despite the rain but were stopped before the last three dances were completed. The event attracted a large crowd estimated at 5,000.

On Saturday 15 July the cruiser HMS *Superb* arrived for her six-day centenary visit. At 9.00 a.m. Commander A. Johnson, commander of the Tyne Division Royal Naval Volunteer Reserves, made a formal visit, being the first of a crowded list of engagements. A press conference at 9.15 a.m. was held on board, and at 10.15 a.m. Rear Admiral W. R. Slayter, Flag Officer Commanding Second Cruiser Squadron, and officers stepped ashore for a visit to the town hall. They were received by Cllr and Mrs R. Bainbridge, the mayor and mayoress, and representatives of the harbour and civic authorities. The mayor and other representatives were taken back to the ship after the reception. The ship was then open to the public from 2.00 p.m. to 5.00 p.m.; launches

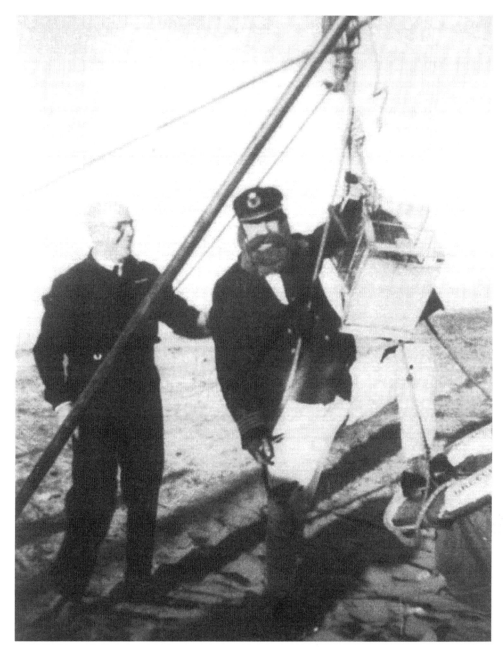

South Shields Volunteer Life Brigade bringing ashore the ship's bearded captain with his birdcage and keg of rum at the end of an exhibition on the South Pier.

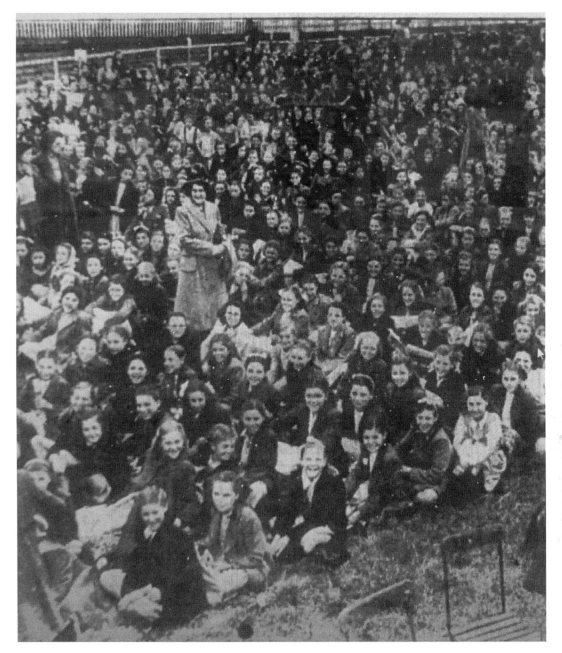

Some of the 4,500 children who took part in the centenary open-air concert in the Greyhound Stadium, Horsley Hill Road.

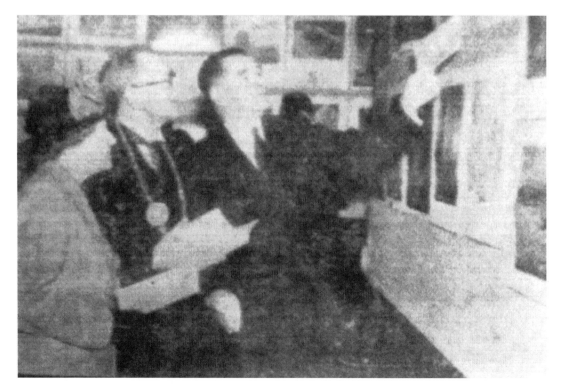

Mayor and Mayoress Cllr and Mrs R. Bainbridge at the International Photography Exhibition at the Public Library, with Mr D. R. Morris, president of the exhibition.

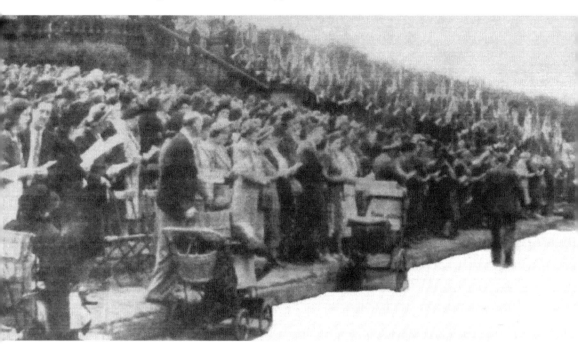

The British Legion floral cenotaph memorial service.

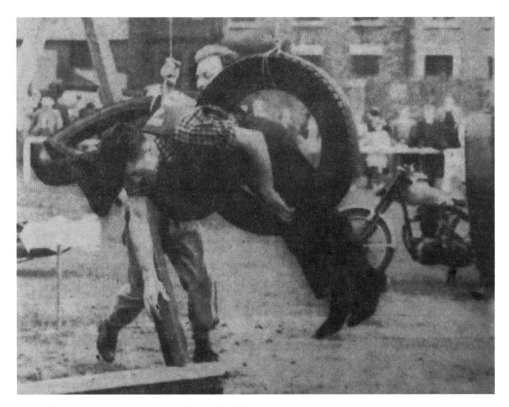

Senior boys demonstrating their physical skills.

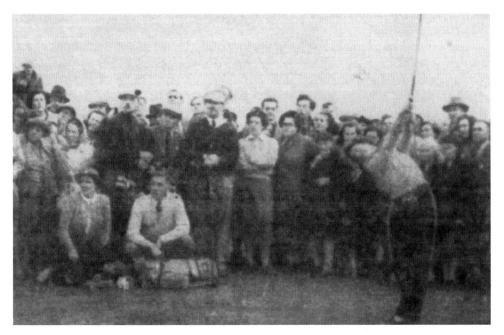

Frances 'Bunty' Stephenson, national women's golf champion, driving from the fifth tee in the centenary exhibition match at South Shields Golf Club.

left Mill Dam Quay to take the public to the ship and many of the townsfolk took the opportunity to look over HMS *Superb*.

A Professional Golf Exhibition match took place at South Shields Golf Course, Cleadon, on Saturday 29 July at 10.00 a.m. and 2.30 p.m. between Max Faulkner, (Royal Mid-Surry), Laurie Ayton, (Worthington), W. Waugh, (South Shields) and K. J. Geddes (Gosforth). The Ladies Golf Exhibition match was held on Sunday 30 between Miss Frances Stephen (English Ladies' ex-Champion and Ladies Team Captain) and Miss Jean Donald (Scottish Ladies Champion and Scottish National Team Captain) at 10.00 a.m. and 2.30 p.m. at the golf club.

From 3.00 p.m. to 6.00 p.m. on Saturday 29 July on the South Pier South Shields Sea Angling Club held a sea angling competition. That afternoon seventy lines were dipped into the sea at the start of five competitions to be held for the highest total aggregate weight of all classes of fish – a silver challenge cup would be presented by Alderman M. M. Barbour. Competitions were also held on the evening of Wednesday 2 August between 6.00 p.m. and 9.00 p.m., Saturday 12 from 3.00 p.m. to 6.00 p.m. and Sunday 13 at the same time. On Thursday 17 the competition was at 6.00 p.m. to 9.00 p.m.

On Friday 4 and Saturday 5 August, Temple Park Memorial Ground had 20,000 visitors to the ninety-sixth Durham County Agricultural Society Show, almost equalling the 1938 attendance. Farmers, from Land's End to John O'Groats, poured into Temple Memorial Park with their livestock for what was described as the 'most costly show ever arranged by the society', with cash prizes totalling around £2,500. Among the attractions were spectacular horse-leaping and obstacle races, sheep-dog trials, Young Farmers' Club stock judging and public speaking, poultry trussing and wrestling Cumberland and Westmorland style along with a demonstration by Cleadon Archers. With a great number of entrants in most of the main categories, judging took some time. A covered bandstand capable of holding 1,000 spectators had been erected with around 400 employees, stewards and catering assistants on the field. Special trains had been laid on by British rail to transport the cattle and sheep to South Shields railway station. Friday was for the judging of the pedigree dairy cattle and Saturday the fat cattle and small livestock. The band of the Durham Light Infantry gave a display each day for those who liked music, then a dog show with all-national championships, the pick of North Country dogs taking part – this being a first in the Society's history.

On Friday 4 to Saturday 12 August the Centenary Bowling Festival took place in all the parks with the 1950 North of England Single-Handed Open Championship final taking place in the North Marine Park. On Saturday more than 800 took part in the competition, with Mr Davison (Jarrow) beating G. Bond (Cleadon) in the final of the men's tournament and Mrs Birkett (British Legion) beating Mrs Black in the woman's final. A gold wrist watch, subscribed to by the towns bowling clubs, was presented to Mr F. Carhill, president of South Shields Bowling Association, for his work as secretary for the bowling association and his work in the tournament, by Alderman M. M. Barbour.

A motorcycle gymkhana and garden fete were arranged for 7 August, Bank Holiday Monday, at Westoe Cricket Ground, Woods Terrace, by South Shields Cricket Club. The event was well attended and a good time was enjoyed by all.

On Tuesday 8, Wednesday 9 and Thursday 10 August the 1st Cadet Battalion, the

Mr J. W. McKeith with son Oliver,
leaving after a day fishing on the pier.

This grand turnout from Annfield Plain Co-operative Society won first prize for the best
decorated exhibit in the county. (Photograph courtesy of Beamish Open Air Museum)

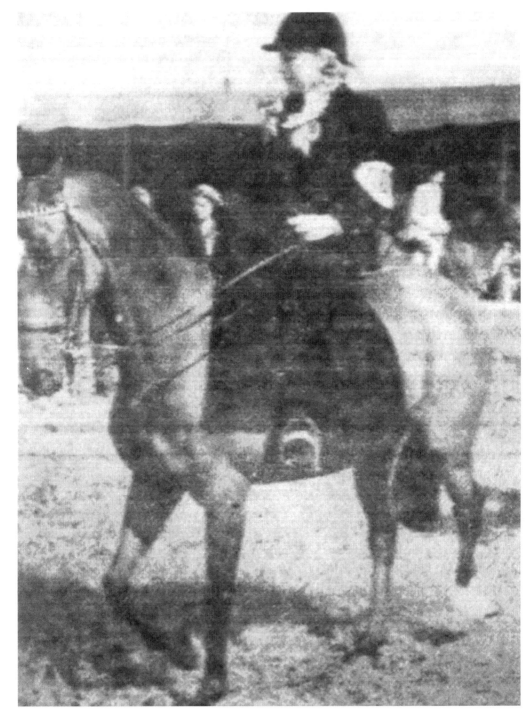

Angela Wilson, the only competitor to ride side-saddle in the children's pony class at the county show.

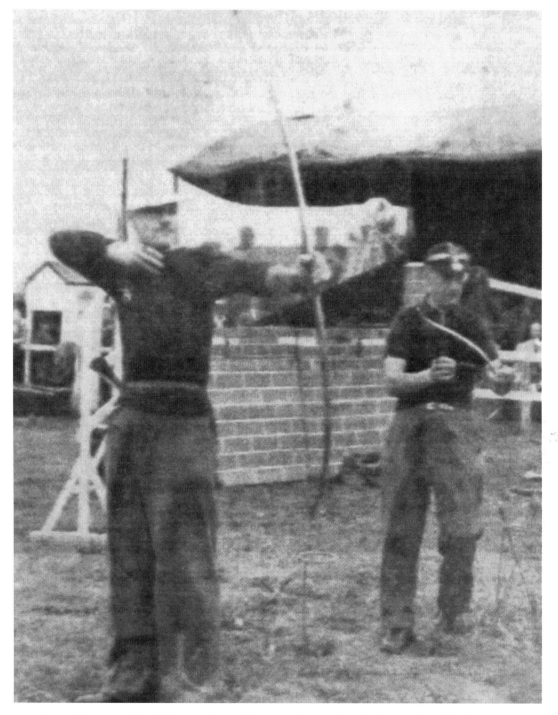

George Brown and Jack Flinton, who took part in the agricultural show archery display.

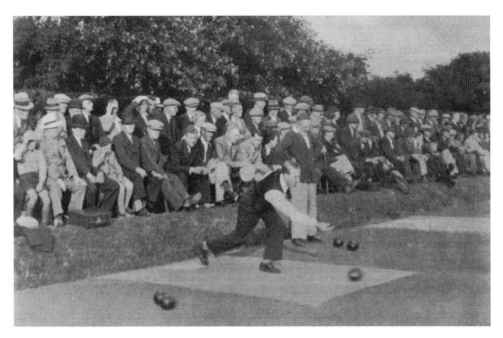

Two of the bowlers taking part in the centenary bowling festival, which was being held over the course of a week.

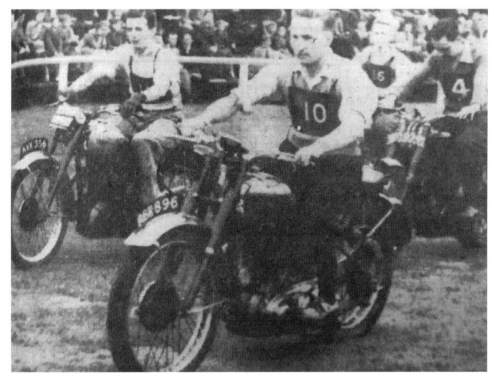

Riders taking part in the motorcycle gymkhana and garden fete at Westoe Cricket Ground, Woods Terrace.

Durham Light Infantry, organised a military tattoo at the Greyhound Stadium at 9.30 p.m. each night. Ignoring the rain, the band, bugles and troops from the 1st Cadet Battalion of the Durham Light Infantry gave the spectators a good display at the Greyhound Stadium; the glitter and khaki, blue and gold, silver and black uniforms, and the kilts of the Highland Light Infantry added a galaxy of colour.

On 17 August, as part of the centenary celebrations, South Shields held an industrial and civic exhibition on the Bents Park, opened by Lord Lawson of Beamish, Lord Lieutenant of County Durham, that promised to be a pocket edition of the British Industrial Fair. The exhibition, which was to last until Saturday 26 (excluding Sunday) was open from 10.30 a.m. to 9.30 p.m. each day, and had exhibitors from every industry in the town. Visitors to the exhibition learned of the numerous industries the town had to offer, many of which they were quite unaware of – the scope of industries and public services and the nature of the town's facilities for power, transport, communication, distribution of goods as well as its manufacturing capability. The total area of more than 20,000 square feet was under canvas, which was just as well as the weather was inclement, torrential rain spoiling Tuesday's exhibition. However, 2,425 people still filed into Bents Park. Over the period of the civic show 38,075 people attended the exhibition, but for the weather many more would possibly have attended, as most days it had rained.

Friday 1, Saturday 2 and Sunday 3 September was the annual flower show held on Bents Park. This competitive exhibition of flowers, vegetables, trade stands and handcrafts was open from 1.00 p.m. to 9.00 p.m. on the 1 and 2 and 11.00 a.m. to 9.00 p.m. on the 3. The trade marquee was a good example of the sort of the exhibit standing, firms from all over the North having sent in displays, with a breathtaking landscape garden built by Donald Ireland, of Ponteland. The show had something for everyone to see.

The firework displays held on the South Beach on Saturday 2 September included a colour replica measuring 24 feet high and 20 feet wide of the South Shields coat of arms, with the dates 1850 and 1950 in brilliant white as a feature. The display took place at 9.00 p.m. just south of the beach chalets. Wednesday 6 and Saturday 9 also saw more firework displays taking place.

From Saturday 2 to Saturday 9 the town had a shopping week and trade pageant. The Mayor Cllr R. Bainbridge cut the tape as a column of more than 450 feet of colour began to move. Music from the first Cadet Battalion Durham Light Infantry played from 2.15 p.m. to 3.00 p.m. and the judging of the vehicles took place in the half-hour before the pageant began. The cadets also headed the parade. The pageant made its way via the Ingham Infirmary, Circus, Dean Road, Stanhope Road, Boldon Lane, Hudson Street, Slake Terrace, Eldon Street, Fredrick Street, Green Street, Station Road, Market Place, and Ocean Road, with the parade dispersing in Sea Road. The vehicles paraded in four groups: 1, Horse drawn; 2, Vans and Lorries; 3, Tableaux; and 4, Trade vans (cleanest engine, smartest turnout). Prizes in the first group were first, £10 and second, £5; in all other groups, £10 first, £5 second and £2 third. More than £200 in prizes were given for a variety of competitions throughout the week and were presented at a dance on Friday 8 September in the Hedworth Hall.

The Mayor Cllr R. Bainbridge opened the second annual shopping week by South Shields Chamber of Trade. The programme for the week included a window

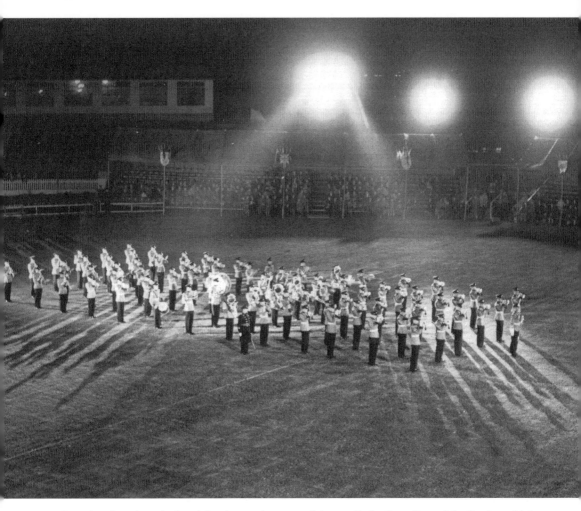

Ignoring the rain – the band, buglers and troops of the 1st Cadet Battalion of the Durham Light
Infantry, are seen preforming at the military tattoo. (Photograph courtesy South Shields Library)

Two of the many young boys having fun on the tractor that was part of the corporation static stand at the Industrial Exhibition in the Bent's Park.

Presenting a prize to June Elms from South Shields High School for her winning entry in the flower show is the Mayoress Mrs R. Bainbridge with Cllr J. Marshall looking on.

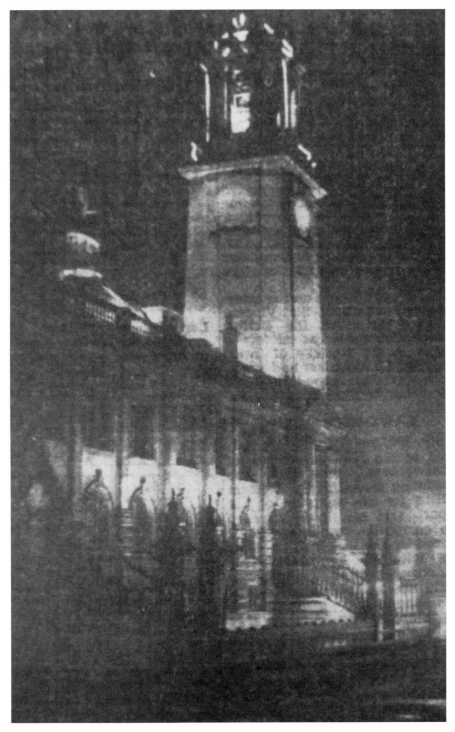

Saturday 2 to Saturday 16; all the public buildings were illuminated. The town hall was one of the many buildings that were floodlit as part of the centenary celebrations.

display competition, treasure hunt, which was open to the public, ideal sales girl with a prize of £5.50, ideal telephone girl, also a prize of £5.50, demonstrations by around twenty local firms open to the public, and a sales service car with loud speaker giving shopping news, toured the area. The pageant prizewinners: group 1, Horse-drawn vehicles, first Vaux Breweries, Sunderland, £10, second Whites Dairies Ltd, £5; group 2, Vans and Lorries, first Craven Dairies, £10, second Smiths Ltd, Furnishers, £5, third Grieves and Co. Ltd, Mineral Waters; group 3, Tableaux, first Steel and Company, Mineral Waters, £10, second S. Newman Ltd, £5, third Barbours Ltd and Hill's Construction Co., £2; and group 4, Trade Vans, first Wright's Biscuits, £10, second Smith's Ltd, Furnishings, £5, third Merry & Sons, Grocers and Provision Merchants.

Sunday 3 September was the day of Incorporation with a Civic Church Parade and morning service in St Hilda's church. The parade left the town hall, Westoe Road, at 10.30 a.m. for a service at St Hilda's church at 11.00 a.m. It was a colourful scene with music from the scarlet-coated Harton Colliery Band and the blue-uniformed People's Mission Band. Contingents from the police force, Special Constabulary, Collingwood Sea Cadets, St John's Ambulance Brigade, the Nursing Division and the British Legion took part.

Also on Sunday, the British League of Racing Cyclists (North-East Section) road race, promoted by South Shields Olympic R.C., staged a senior and junior event starting from the North foreshore and finishing at the South Foreshore, the senior starting at 1.00 p.m. and finishing at approximately 5.00 p.m. and the junior starting at 1.20 p.m. and finishing at approximately 3.20 p.m.

Running from Monday 4 to Saturday 9 September was the Gilbert and Sullivan Operatic Society's production of *The Drunkard*, in St Aidan's Hall. This original melodrama carried playgoers back 100 years when they entered St Aidan's church hall. The attendants selling the programmes, wore frocked coats and beards, and the women who showed them to their seats wore skirts and bonnets. George Parker played Squire Cribbs and Jack Gallagher the slow-witted hero. Music was provided by the Summerson Brass Quartet and the G and S pianist. Tickets, which could be obtained from Wiggs, were 2s and 6d (a little over twelve pence), if booked in advance.

The presentation ceremony of the 'Freedom of the Borough' was held at the Regent Cinema. This ceremony was to offer the honorary freedom of the town to six members of the public in recognition of the recipients' service to the town or nation in their various spheres of activity. Those awarded were the Right Honourable James Chuter Ede, PC, MP, DL, JP, Sir Amos Lowery Ayre, KBE, DSC, Lord Wright of Durley, PC, GCMG, Alderman Edward Smith, JP, Alderman Charles Henry Smith, JP, and Robert Pow Fernandes, Esquire. Each of the six men received on oak casket lined with cedar. Each casket had a scroll enclosed and an inscription on a silver plate inside the lid which reads 'The Honorary Freedom of the County Borough of South Shields conferred upon … 4 January 1950.' This date was when the town council passed the resolution conferring the freedom of the borough on these six men. The caskets were mounted on silver balusters with the coat of arms, in enamel on silver in heraldic tinctures, on the outside of the lid. On each side were the silver heads of the river god Tyne, and on the front are engraved monograms of the new freemen.

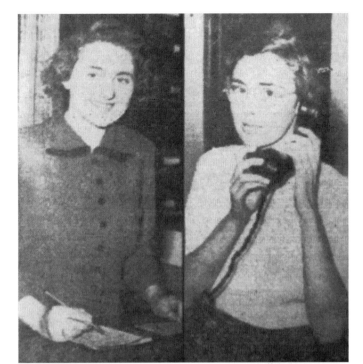

On the left, Miss Dorothy Smith, shop assistant at Chris B. Watson's outfitters, chosen as the most courteous shop girl, and on the right Miss Audrey Chambers, of Messrs Marrs Tobacconists, selected as the ideal telephone girl, in the contest organised during South Shields shopping week.

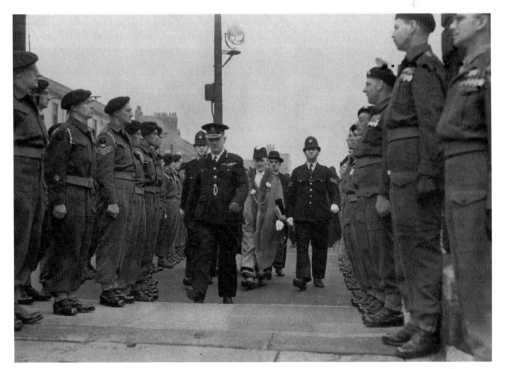

Walking through a territorial guard of honour, the Mayor Cllr R. Bainbridge and civic officials, led by the Chief Constable Mr T. S. Humphrey, arriving at St Hilda's church for the centenary civic service, which was held at 11 a.m. (Photograph courtesy of South Shields Museum and Art Gallery)

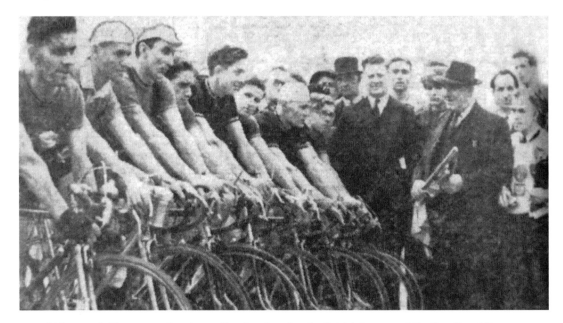

Alderman J. Garnett getting the cyclists lined up for the British League of Cyclists Road Race at the North Foreshore.

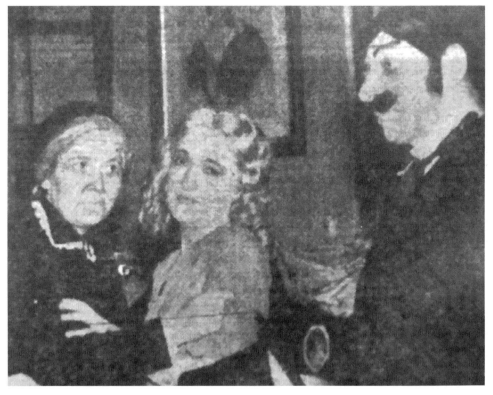

Presented by South Shields Gilbert and Sullivan Operatic Society in St Aidan's church hall, *The Drunkard*.

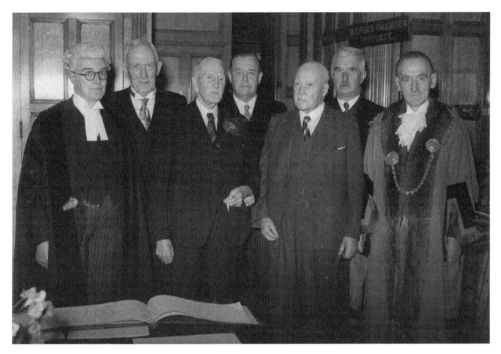

Town clerk Mr H. Ayrey, Alderman Charles Henry Smith, Alderman E. Smith, Sir Amos Lowrey Ayre, Mr Robert Pow Fernandes, The Honourable James Chuter Ede, Home Secretary, MP, DL, JP, with Mayor Mr R. Bainbridge at the ceremony of the Freeman of the Borough.

On Sunday 17 September an open rifle competition was held at Whitburn Rifle Range, organised by South Shields Home Guard Rifle Club. The competition was open to all TA units and Civilian Rifle Clubs. Individual and team competitions were held and over 100 entries took part in the competition. The Lieutenant Colonel R. S. Chipchase Cup for the team with the highest total aggregate was won by the third team of the 8th (South Shields) Durham Home Guard Rifle Club, while the Major M. W. Thompson Cup for the highest individual score was won by W. Gilroy, of the 8th Durham Home Guard with a score of 137.

On Monday 18 to Saturday 23 September the Centenary Pageant *Vision*, in which the leading local amateur dramatic and operatic societies combined, was produced in St Aiden's Hall.

On Thursday 27, Friday 28 and Saturday 30, a performance by the Westovian Dramatic Society was held in St Aiden Hall. The Spanish comedy *Woman Have Their Way* by the Quintero Brothers made a memorable play for the town centenary. The play's stress on human foibles rather than man's greatness made the audience not only laugh at the players but more heartily at themselves.

From Saturday 7 to Saturday 28 October, South Shields Library held a Centenary Art Club Exhibition by South Shields and District Art Club. One hundred sketches and paintings created by the art club were hung on the museum walls in the library. Many of the art club paintings are of a local interest.

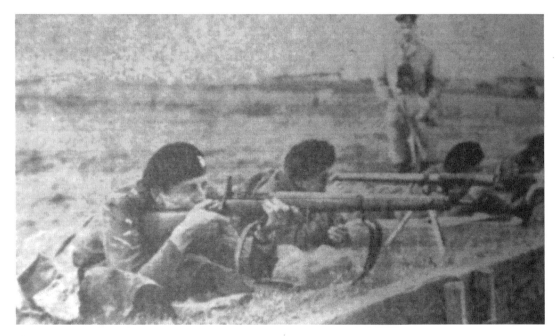

NCOs with men of the 43rd Royal Tank Regiment (TA) competing in the South Shields centenary shoot held at Whitburn Range.

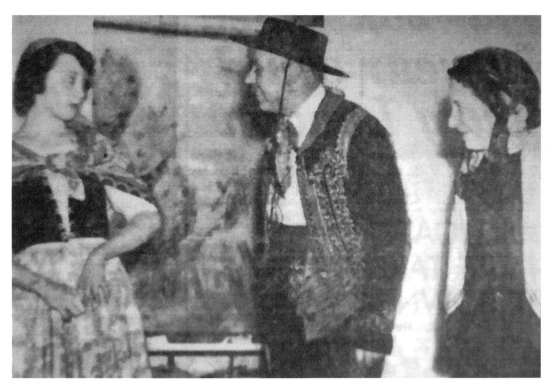

The benign Don Cecilio (Arthur Siddle) and deaf old gossip Fantita (Jean Sherwood) hear a village girl (Betty Douglass) tell of her sister's misfortunes in the play *The women have their way*.

Two members of the library staff admiring some of the one hundred artworks on show in the South Shields Centenary Art Club Exhibition, which was to open the next day.

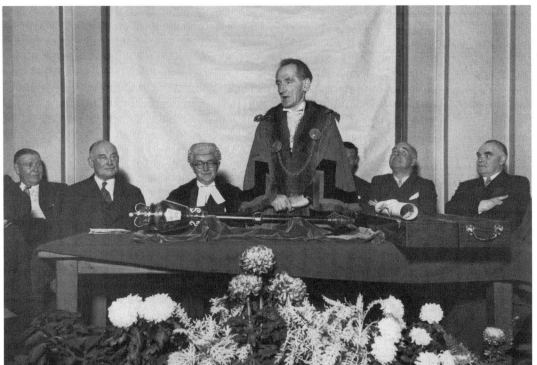

The presentation of the ceremonial mace to Cllr Robert Bainbridge, Mayor, held in the town hall reception room on Thursday 9 November 1950. (Photograph courtesy of South Shields Library)

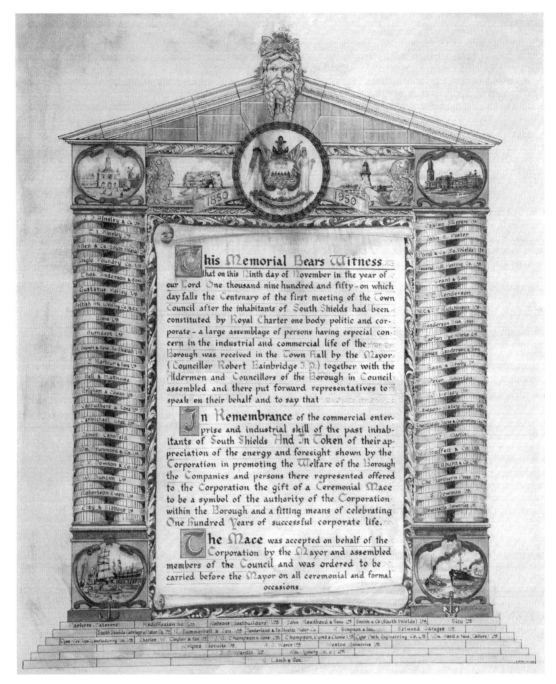

Together with the mace, the Lord Mayor was presented with this beautiful scroll with the names of all the contributers to the cost of its manufacture. In all sixty-five companies contributed to the cost, from J. D. Ainsley & Co. Ltd, to Elsy & Gibbons down the left side of the Scroll, Eskimo Slippers Ltd, to Newcastle Breweries Ltd. on the right side and Parkers Caterers to W. M. Young (S. S.) Ltd on the base. G. Lamb & Son was added underneath. (Photograph courtesy of South Shields Museum and Art Gallery)

Winds of Change

A great change was sweeping its way through South Shields in the third quarter of the century. The wind blustered its way effectively and vigorously through great swathes of the town and surrounding countryside. Much of our surrounding farmland would disappear for the building of both private and council housing as well as some of our old familiar sites in both Harton Village and along the riverside. Horsley Hill Farm, better known as Hemsley's Farm, had been in John Hemsley's family since the 1880s and, situated near Horsley Hill, was one of three farms that had stood in the area. Standing in rural tranquillity, it was one of the first to go. It had once stood in the heart of the country and ran towards the sea before the building of the Coast Road. It had been gradually hemmed in by the encroachment of houses prior to and just after the Second World War. First came the private housing built from 1934 on the east side of Highfield Road, between Grosvenor Road to North View. Then in 1937, South Shields Housing Committee recommended the council allow the North-Eastern Housing Association to build 350 houses on the Little Horsley Hill Farm, which had been owned by John Blenkinsopp Phillips, to the east of Cheviot Road. These are the houses from St Cuthbert's Avenue to Warkworth Avenue. The road between High Meadows and St Cuthbert's Avenue had not been completed before the war.

In 1955 the Hemsley Farm was demolished to make way for 200 private houses that were to be built on the site by William Leech (builders) Ltd. Two of the privately owned homes were to be occupied by the families that had lived on the farm before the builders moved in. Hemsley Road was named after the farm's late occupiers.

South Farm, better known as Colley's Farm, lay just behind Westoe Village to the south and had been in existence from around 1398. It was taken over by Ralph Colley and his family in 1865. The farm was small by some standards – only 67 acres. The old farmhouse, with its stone-flagged floors, beamed ceilings and oil lamps, was quite a picturesque place with a whitewashed stone outbuilding. Colley's farm had the oldest and last enclosed field in the area. The farm had been in decline for some years and, with its surrounding fields and pastures, where their cattle had once grazed, gradually being nibbled away for development, what remained was demolished to make way for the building of a new Marine and Technical College. In 1951 the corporation had taken over the Marine School on Ocean Road from the Winterbottom Foundation

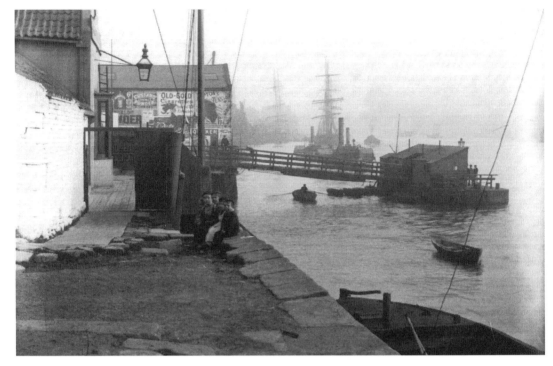

The *Ha'penny Dogger* direct ferry landing, Comical Corner, Wapping Street. (Photograph courtesy of Andrew Stenton)

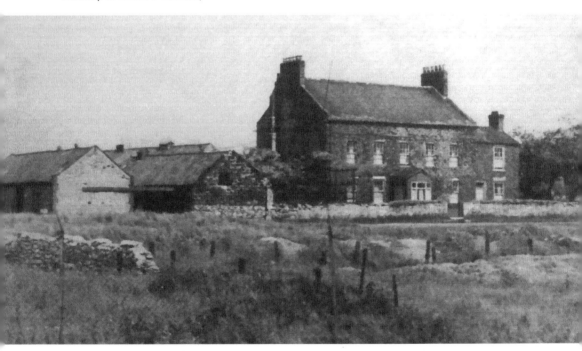

Hemsley's Farm, once in the rural setting of Horsley Hill, was demolished to make way for private housing.

and purchased 5 acres of Colley's farm at a cost of £780. In 1952 work began on the construction of the Marine and Technical College and, on 10 June 1953 to commemorate the college being built, Right Honourable Chuter Ede MP cast the base of the column supporting a 16-inch telescope, and the construction of the observatory commenced in 1955.

As the development plans for South Shields progressed, more of the farming community were depleted. Within a short time South Shields had become almost entirely urban with few farms remaining. Harton Down Hill farm, which had enjoyed planting and grazing rights for their crops and mixed herd of Aberdeen Angus and short-horn cattle on the Lees, was given notice that at the end of 1957 this would be no longer available for grazing purposes. Mr Lund, the manager of the farm, and others were told that the 155-acre coastal common would be developed to provide a seaside open space second to none in the North East and were given a year's notice. Without these rights the farm soon went into decline and ceased to exist not many years later.

Harton Village also had the winds of change forging its way through its small rural community. Incorporated into South Shields in 1919, it was now to see some of its older building being demolished for the widening of the Marsden Road. One such building was the village post office of A. Caffery, grocer. This beautiful building on the corner of St Mary's Terrace had bull's eye (bullion) glass in the upper portion of its bevelled display window. Alma Caffery had served the community of Harton Village for more than forty years when her grocery shop was demolished in 1955 for the widening of the road to Marsden.

The Whitburn Coal Co. train, better known as the Marsden Rattler, stopped carrying passengers in 1953. When built in 1874, it was never considered as a passenger train; it was purely built for the transportation of coal, although it did carry miners from South Shields to the pit at Whitburn. The owners suddenly saw an opportunity to make the train pay for its self and to make a profit running it. In 1885 the first members of the public were allowed to travel, however the Board of Trade stopped the passenger service until certain conditions were met. The passenger service was officially allowed to resume in 1888 with the Board of Trade's blessing. The Marsden Paper Mill, which opened in 1889, no doubt boosted the passenger numbers. The train, with its familiar wooden carriages, ran from Westoe Lane Station, Mendelson Road, now Spohr Terrace, to the coast, along to Marsden Cottage Station, which had been added in 1910 beneath Blackberry Hills, Marsden Station, which was between the Marine Grotto public house and the Lime Kilns, then on to Whitburn. During the war the *Rattler* was the only means of transport to and from Whitburn, the Lime Kilns and Marsden Paper Mill. With the increasing threat of invasion, coastal defences had to be stepped up. The sealing up of the seafront was ordered by the military authorities and the trolley bus service was suspended. The *Rattler* was the last privately owned passenger train in the country; with the closing of the Rattler line it also signalled the closure of the smallest reputed railway station in England, Marsden Cottage Station, sometimes known as the Holt.

On 23 November 1953 a small fleet of carriages left Westoe Lane Station at 9.58 p.m. silently slipping away from the platform, disappearing under the footbridge that linked Spohr Terrace to Iolanthe Terrace and Hunters Terrace, as it had done for the

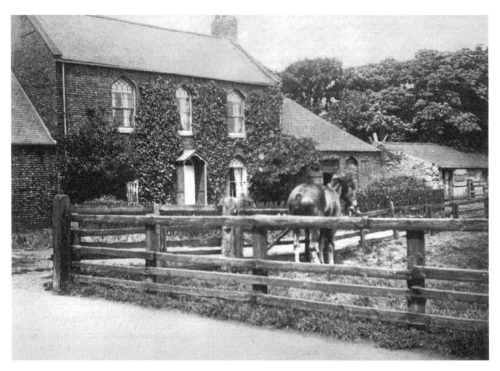

Colley's Farm, Westoe where the Marine and Technical College now stands on the site. (Photograph courtesy of South Shields Library)

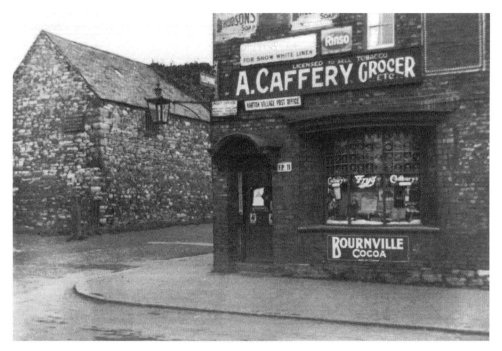

Alma Caffery's grocery store and post office in Harton Village, demolished in 1955 for the widening of Marsden Road. (Photograph courtesy of South Shields Library)

last seventy years, and disappeared into history as a passenger train. The line remained open as part of the Mineral Line to handle the substantial amount of coal being extracted from Boldon, Harton and Whitburn Collieries to be brought to the washers at Westoe Colliery.

On the river the Whitehill Point Ferry operated between Whitehill Point just west of the Commissioners Quay North Shields and just below the Middle Dock public house, West Holborn. In 1941, the service was discontinued due to damage caused by enemy bombing, but was resumed in 1951. Unfortunately the service only lasted until September 1952 when it was discontinued altogether.

The Direct Ferry Service can be traced back 107 Years ran from Kirton's Quay, Wapping Street, to the New Quay, near the Market Place in North Shields, better known as the *Ha'penny Dodger*. The ferry had been crossing the river taking both passengers and goods back and forth, running a twelve-minute service from 5.00 a.m. until midnight. Since the end of the war passenger numbers had been in decline. With the demise of the area people were no longer walking along what had once been a quaint street to the ferry, and it ceased running on 28 August 1954.

In 1957 after 133 years, the South Shields Gas Co. was to cease operations in the town, but its legacy can still be seen today. On 24 March 1824, by deed of covenant, the first gas company had been formed. A place called Paradise, on the south side of the Mill Dam, was chosen for the construction of the first works. By October of that year the first gas was supplied to shops and houses. Five years later street lighting commenced, but only after the establishment of the Improvement Commissioners. There used to be a number of gasometers in the town. There was one in Coronation Street, which was possibly where the first one was originally built, and one in East Holborn, Oyston Street, that can still be seen today, although the coke works were demolished and the increased supply of gas was now being received from Monkton Coke Works.

One of the biggest changes in the town was the mass movement of people from the areas they had known for over a century, as most of Laygate, Tyne Dock and Ocean Road south side was to be redeveloped.

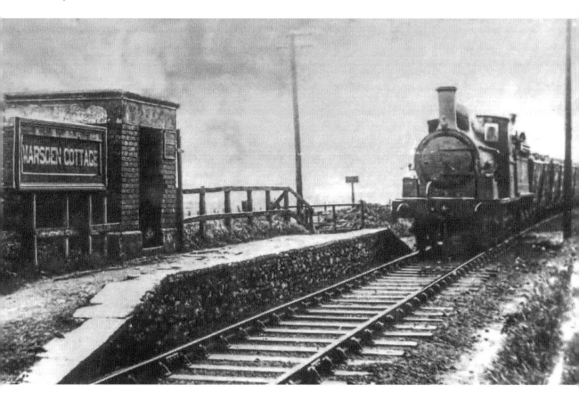

The Marsden & Whitburn train, the *Rattler*, with its steam locomotive and passenger carriages at Marsden Cottage Station on 29 April 1952.

The walkway down to the Whitehill Point ferry landing. In the background to the right is the Middle Dock Hotel; in the foreground is the Middle Dock graving docks.

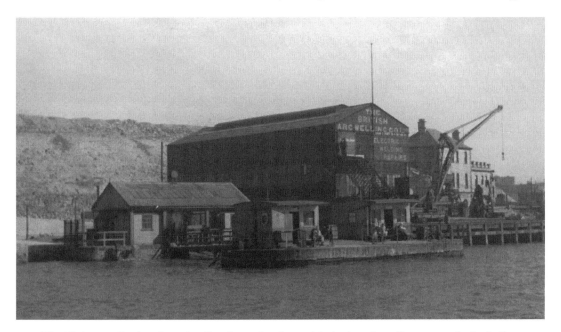

The *Ha'penny Dodger* ferry landing from the river, with the housing all gone – only the ballast hills are to be seen where once a vibrant community lived. The British Arc Welding Co. is one of only a few employers along this part of the river. This ferry went directly across the river to the New Quay near North Shields Market Place, but with the decline in passenger numbers it became uneconomical to run. (Photograph courtesy of South Shields Library)

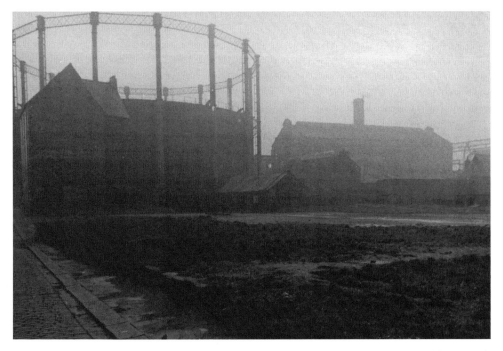

Gasometer & Coke works on the corner of Oyston Street and Garden Lane. (Photograph courtesy of South Shields Library)

3

Housing

In the early years most housing had been built along the riverside. Before 1820 South Shields was considered to be little more than a hamlet with Commerce Street, Long Row, Wapping Street, Shadwell Street and Pilot Street, more commonly known as the Kings Highway or the High Street, with many quays' running from them having houses built of different shapes and sizes many at such a precarious angle that they would be almost touching at the roof. The high end of the town, Holborn, had mostly been the industrial end with the salt industry dating back to at least 1499 and the glassworks from the 1730s. Again houses were built in various styles and wherever the fancy took them – planning permission did not exist until 1856. Many houses had been built on the ballast hills that had grown up along the river from ships coming into the quays to collect the salt, glass, coal and other commodities to be traded around the world. In 1809 Temple Town was built to house the men from all over the country who came to work in the new pit that had been built there by Simon Temple. Slake Row and Colliery Square were cottages and quite small.

Corstorphine Town was built in the 1840s by Robert Corstorphine who had visions of a New Market area to the west of the town. These streets were more substantially built than some of the previous houses and built in rows rather than haphazardly, some of which are still standing today. Many houses, especially the ones along the east end of the river, had already been demolished before the Second World War as with no sanitation they were classed as a health risk as well as being in danger of collapsing. Many more were bombed during the war. In July 1933 the chief housing inspector, Mr R. Ayre, revealed 'that of the 200 houses recently demolished by the corporation no fewer than 150 had suffered great damage from the furniture beetle, and more than 10 per cent were in a most dangerous condition'.

Housing was one of the more pressing issues in the 1950s, not only because of the destruction of many homes during the Second World War but because of the slum-clearance schemes that took place in the next eleven years – thirty-one schemes involving around 3,400 families. Many of these families to be rehoused were from the Laygate and Tyne Dock areas of the town. Houses in the Ocean Road and Mile End Road area of the town, as well as some of them in the Laygate area, were among the worst affected.

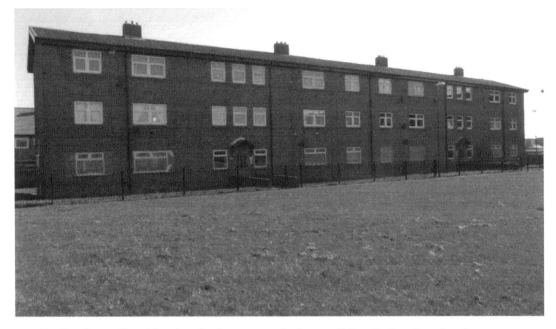

Farding Square flats, Marsden, the first purpose-built council flats for housing after the war.

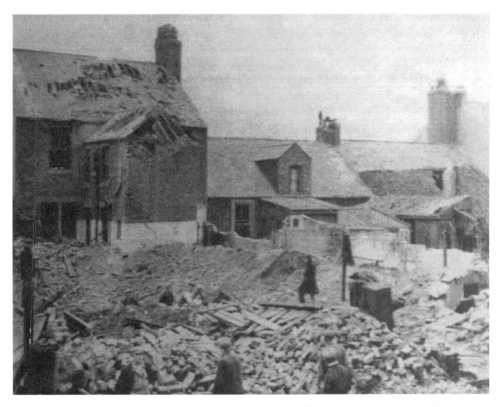

Pearson Street and the back of Law Road after the air raid of 8 September 1940. (Photograph courtesy of South Shields Library)

Some families had temporary homes, including Marsden Camp on Lizard Lane, which had been a holiday camp before the war. North Pasture Camp and The Lawe were used for army personnel during the war, and as soon as they moved out house-hungry folk moved in. Others moved into the prefabricated houses that had been quickly erected in areas such as Denmark Street, Cheviot Road and Mitchell Gardens areas of the town. Although these were little more than the equivalent of a flat-pack, they were lovely and warm. In July 1950 the Borough Engineers asked for tenders for the erection of ten blocks of two dwellings – seven blocks of four dwellings and three blocks of six dwellings for the Marsden Road Housing Estate. Tenders were to be submitted no later the 17 July 1950.

For the first time the council was to include the building of flats as part of their rebuilding program that came in the wake of the clearance scheme. In February 1952 the first of these flats was opened at the cost of over £80,000. There were seventy-two in Farding Square, Marsden. These consisted of three-storey blocks with twelve flats in each block. These flats were built in a horseshoe arrangement with a grassed playing area in the middle for children to play, as there was only a very small area behind each block of flats. These flats became popular and because of their popularity, over the next year the council opened fifty-four flats in River Drive at a cost of £84,000.

In August 1951 tenders were invited for the erection of four three-storey blocks of twelve flats, three single persons' dwellings and one block of six garages, on the land in Wellington Street adjacent to River Drive.

Two larger schemes were to follow on the success of these, at Laygate and Tyne Dock. The first was the St Mark's redevelopment scheme, at Laygate. On 3 July 1950 a notice had been placed in the *South Shields Gazette* giving notice, that the council of the Borough of South Shields under section 29 of the Housing Act, 1936, had made an order which was submitted to the Minister of Health for confirmation to compulsorily purchase the land and dwelling houses. Part one of the clearance area meant the demolition of Dixon Street, Raglan Street, Orange Street, Hardwick Street, Bedford Street – and part of Maxwell Street – Nos 178 to 252 on one side and Nos 133 to 207 on the other side. Victoria Road was also partially affected – Nos 46 to 76, along with Nos 32 to 44 Princes Street and No. 1 Todd's Buildings. Part two included the land and premises of No. 3 Raglan Street (Queen's Head public house), No. 60 Orange Street and No. 3 Bedford Street (Prince Albert public house), Laygate Lane from Dixon Street to 189 Laygate Lane, which included the Baptist Tabernacle church and church hall. Nos 2, 3, and 4 Todd's Buildings and the land behind which extended to Victoria Road along with St Mark's church and school in Hardwick Street. Work started in 1958 on this 10-acre site at Laygate. These flats were to be centrally heated 'super flats' and the £500,000 development, the first of which was opened in October 1959, were to be built in blocks, each three stories high. These communities that had lived together for generations were split up and sent to the new housing estates that were being built around the town.

The town was also expanding rapidly to the west, with new houses being built from Wenlock Road to Peel Gardens and south to Bainbridge Avenue and part of Winskell Road. The Prince of Wales public house, which stood adjacent to a row of terraced

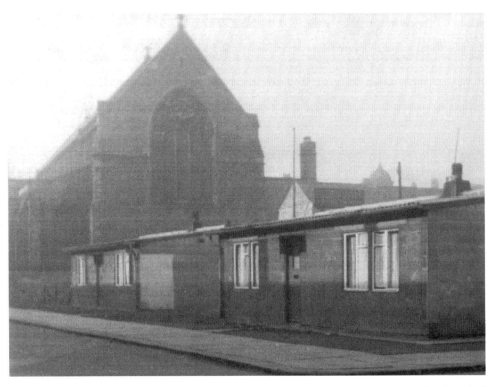

The prefabs built behind St Thomas' church, Catherine Street, to house those families bombed during the Blitz. (Photograph courtesy of South Shields Library)

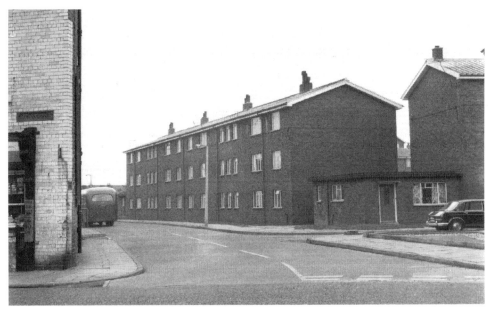

The new flats built in the River Drive area of the town, as seen here from Lawson Street, were built to replace the old houses of Lady's Walk, Wellington Street, Wellington Place, Long Bank and Dairy Lane. (Photograph courtesy of South Shields Library)

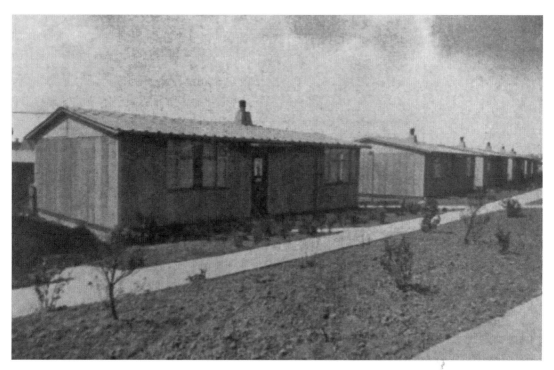

Temporary prefabricated bungalows on Cheviot Road. These were only supposed to last for ten years but were used for over twenty before being replaced. Most people loved living in these bungalows and made them very comfortable and did not want to leave them.

These are the 'super flats' on the St Mark's redevelopment that were built to replace the old terrace housing around the Laygate area. (Photograph courtesy of South Shields Library)

houses, the railway cottages, which wer part of Green Lane West, Green Lane Villas and South View Terrace, were demolished, and tenants were moved to the new houses in Whiteleas and Biddick Hall. With the town council acquiring West Simonside farm in 1953, by 1955 Simonside was one of the biggest estates of our ever-expanding town with its own shops, church and a workingmen's club.

Although thirty-six new council houses had been let to new tenants in July and August 1950, the council waiting list had increased to 4,782, even though 2,372 permanent post-war houses had already been built.

4

Childhood

For children living on one of the new estates in the 1950, this was a time for making new friends and exploring a different environment. The new houses had indoor toilets – no bedpans under the bed or going down the yard to the privy and no back lanes with washing hanging out on a Monday. The front street became the playground. Most of the new estates were bordering onto farmland or open fields, making for extra adventures. Most people furnished their homes with oil cloth floor covering, canvas and clippie mats, which were put in front of the fireplace in the sitting room

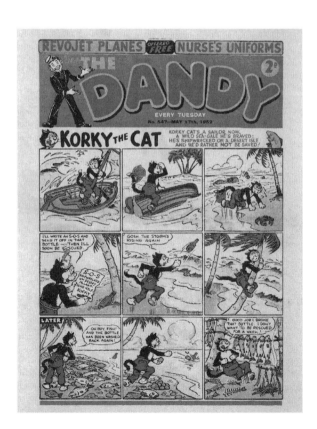

The 17 May 1952 *Dandy* comic, with a 'Korky the Cat' story on the front and 'Keyhole Kate' and 'Rusty' stories on the back cover. (Photograph courtesy of South Shields Museum & Art Gallery)

and beside the bed so you had something warm to stand and utility furniture. Those on the Marsden Estate also had a wash house attached with a boiler and cold-water tap. Most of the families moving to one of the new estates that had sprung up after the war had moved in around the same time from various parts of the town, some from bombed-out houses, others from the clearance areas, and also people like ourselves escaping overcrowding.

For those babies not being breastfed there was National Dried Milk, which was modified full-cream milk, fortified with vitamin D (1) in a tin equivalent to 7 pints of milk. Baby milk, cod-liver oil and orange juice could be bought at the clinics where babies were checked on a regular basis. Many children would be weaned on Farley's Rusks mashed up in milk or given as a biscuit as a teething aid before being introduced to more solid mashed-up meat and vegetables from their mother's plate. Children tended to eat a healthier diet with a greater intake of bread, fresh fruit, milk and less sugar in drinks because in the early 1950s food was still been rationed.

Breakfast consisted of porridge; lunch was corn beef hash or bubble 'n' squeak; dinner would be stew, mince with dumplings or homemade pies and fish on Fridays. If mum could get hold of a sheep's head it would make quite a few meals as nothing was wasted. The brains and tongue were cooked as separate dishes, while the head was made into a broth. My dad would even eat the eyes as a delicacy. Tripe was another cheap meal, sometimes raw with salt and vinegar or cooked in milk with onions. Sheep's trotters and pig's trotter were also made into a stew.

Playing in the street was not a problem as no one owned a car and the milkman delivered before 7.00 a.m., the Co-operative vans usually came on Tuesdays and Saturdays, one from the Jarrow and Hebburn Co-operative Society, the other from the Boldon Co-operative Society. Mam was in the Boldon Co-op and we had to remember her dividend number, or 'divi' as it was more commonly called. Mam's was 10768, so when we went to the van she would not miss out on the 'divi' paid out. Usually this was at the end of the financial year depending upon the profit the Co-op had made, how much mum had spent, would determine what was received. In 1952 the Jarrow and Hebburn Co-op paid 1/9d in the pound (almost 9p). This would be put away to help on a rainy day or for Christmas.

G. E. Evens & Son's, 'pop' van would also call on a Saturday afternoon and besides selling lemonade it also sold dandelion and burdock, sarsaparilla, ice cream soda and cherry ade, all at 5d (around 2 pence) a bottle.

The knife-grinder who sharpened scissors, knives and other blades came regularly. The screech of metal on stone from the knives and garden implements was piercing. In the summer the Davis ice cream van would come round playing a tune to attract children to buy their ice cream or the Walls ice cream man would come round with a fridge on his tricycle.

A length of rope stretched across the street would be tied to the lamp post for skipping through – everyone would join in. 'Block the bay' was a game we played in the winter, using the lamp post as the bay. It was harder to find us, especially when some houses had privet hedging. In the summer the boys would use the plant pots at the end of the path as wickets for playing cricket.

Clippie mat hanging on the line waiting to have the dust beaten out of it. These were made on large wooden frames with hessian stretched across, with old cloths cut up to clip in and out to make the pattern.

Starting school, the classroom was very big and daunting. Around the walls were placed large dominoes for learning your numbers, the alphabet ('A is for apple, B is for ball, C is for cat' etc.), and underneath were bookshelves with simple reading books. At the end of that wall were our two and three times tables; in the corner was a little house for playing in beside a small sandpit. Each morning we would be given a one-third-pint bottle of milk at playtime. In the winter if it had been put to near the heating it would be sour and had to be thrown out. The desks in school, where we used too leave our books, pens and pencils in from day to day, all faced the blackboard.

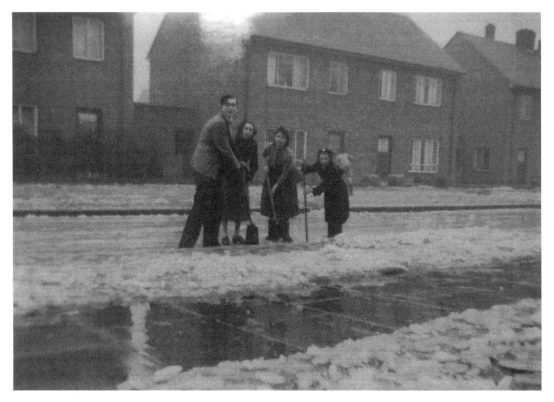

Glen Matthews, Moira Clarke, Ann Murtaugh and Eileen Clarke clearing snow in Ede Avenue, winter 1959.

Prayers were said at the start of the day in assembly; at lunchtime we said grace before meals. On returning from lunch we would say grace again and prayers were said once more before going home at night. Not many children stayed to school dinners – mostly those on free school meals. For those having to pay, it cost 9d a day (just over 4p) for two courses. It was cooked in the school kitchen and knives, folks and spoons for dessert were set out on the tables. Most children would go home, leaving school at 12.00 p.m., to be back at 1.45 p.m. in the summer and 1.15 p.m. in the winter. In the summer we left school thirty minutes later than in the winter because of the lighter nights. Discipline was strict, but teachers, with forty-two children in a class, had to be, But they were generally fair and respected. Playgrounds had metal climbing frames so care was taken when using them.

Children were encouraged to save money at school through the School Savings Movement. In which South Shields was the best in the country in December 1954 on account of having the highest proportion of regular savers and saving more per head as well. Money was saved through the Trustees Savings Bank and could be withdrawn

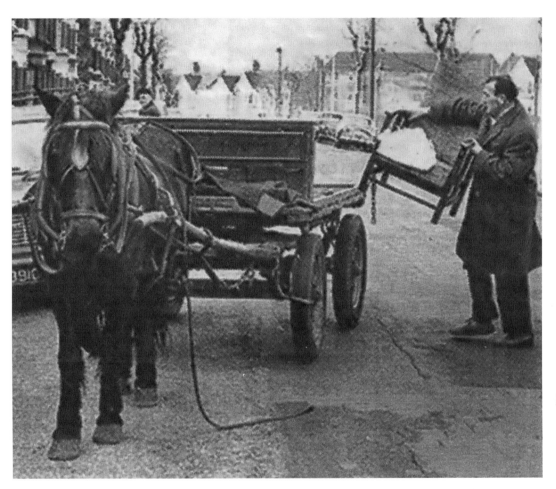

Once a week the Rag and Bone man would come around with balloons tied to his cart. We could never understand what he shouted but we knew the voice. Depending on the amount of 'rag' cloths and/or bones you gave him, dictated the item you received. You might get an earthenware mixing bowl if you were lucky.

at any time, but the longer it was left in the better the interest. We were encouraged to try and save 6*d* a week.

The boys always seemed to have the most fun, playing marbles on the grass on the way home after school while we girls could only look on. When playing Cowboys and Indians the girls were always the ones the boys tied up. The boys often went chasing the '*Rattler* train' from Whitburn. They would also go sliding down the hills in an old tin bath or on an upturned bin lid with the handle removed, while the girls were expected to play with dolls or dress up as nurses. Stilts would be made from two long pieces of wood

with a triangular wooden piece nailed onto it around a foot (30 cm) from the ground. Another thing the boys would make was a boogie out of a soap box and old pram wheels – great fun for going down hills or just pushing each other around the streets in.

The coronation of the queen on 2 June 1953 was quite an eventful day. We went to school in the morning to take part in a pageant in the schoolyard, and we were given a brooch in the shape of a crown with a red, white and blue ribbon. An older girl played Princess Elizabeth and one of the boys played Prince Philip, with six other girls as ladies in waiting to carry the train. After the 'coronation' we all received a gift of a coronation mug and a coronation tin, which had an image of the queen's head on the front and a handkerchief and sixpence inside, as well as a mugs or cups and saucers. After this we were all allowed to go home to listen to the coronation on the wireless or, if you were lucky, to see it on a television.

Mr and Mrs Matthews, our next-door neighbours, had bought a television for the coronation and invited some of the neighbours in the street, along with their own relatives, to watch the coronation in their sitting room.

Television in 1953 would start with the test card so that you could adjust the set, then from 3.15 p.m. to 4.00 p.m. would be *About the Home* for women, followed by children's television for the very young from 4.00 p.m. to 4.15 p.m., which included either *Watch with Mother, Andy Pandy*, with Audrey Atterbury and Molly Gibson pulling the strings,, *Bill and Ben the Flower Pot Men, Muffin the Mule*; or the *Wooden Tops*. Then from 5.00 p.m. to 5.35 p.m. was children's television with *John Wright's Marionettes*; *Children's Newsreel, Cal McCord* the cowboy with the horse called Ladybird, or *Prudence Kitten*, with Annette Mills among others.

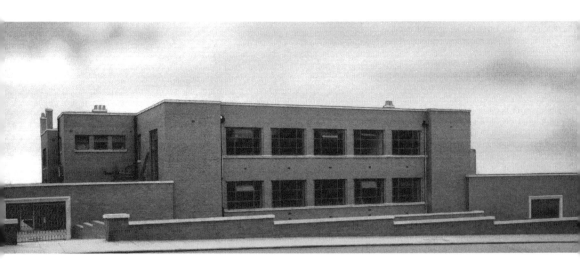

The Health Clinic at Chichester where all the children would go to have their health checks and be vaccinated from birth. It also had a dentist department where we would have our teeth looked at, with the ever present smell of disinfectant. Baby milk, orange juice and cod liver oil could also be bought here. The clinic was built on what had been the site of St Mark's vicarage. (Photograph courtesy of South Shields Library)

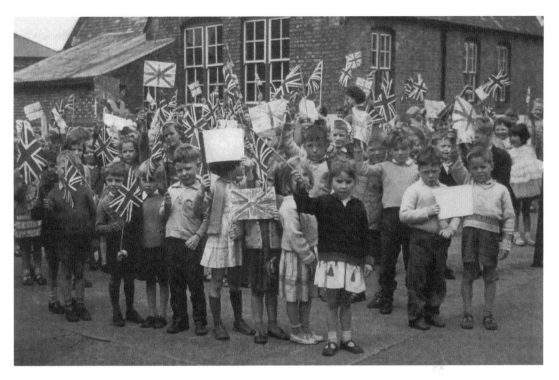

Schoolchildren in the schoolyard on the morning of the coronation. (Photograph courtesy of South Shields Museum & Art Gallery)

Each year in July there would be a garden fete in the Medical Mission Sisters of the Convent in Westoe Village; this was usually in aid of one of the many charities of the time and was often opened by the mayor. The Women's Guilds would have stalls that sold items that had been made by them alongside hoopla stalls and others for confectionary like toffee apples, toffee, and candy-floss on sticks. Plants would be on sale in one of the greenhouses belonging to the convent. Inside, the nuns would be selling afternoon tea with an array of homemade cakes that they had made. It was always an enjoyable afternoon.

During the summer parents would get together to hire one or more 'Hall Brothers' coaches to take their families on a day trip to Saltwell Park, Crimdon Dene, Seaton Carew or Morpeth. The Women's Guild trips were also popular. They would go to Jesmond Dene, Bolam Lake or Heddon-on-the-Wall. On one occasion we went to the Lake District, which took quite a long time to get to, but it was worth the early start. The coaches were to collect us at 8.00 p.m. beside Westoe Fountain bus stop.

Down Hill Farmyard was used as a shortcut when going to Marsden beach. The cows in the field would just look bored, and if we were seen we would getting told off by the farm manager, Mr Lund, but it never stopped us doing it the next time. Most of the summer was spent on the beach, playing on Blackberry Hills or Cleadon Hills, or playing tennis in one of the parks. To play tennis in Cleadon Park you had to wear plimsolls and it cost 6*d* (just over 2p) to get in. Other times we would go playing in

Outside Mr and Mrs Matthews' house after watching the coronation on their television. Glen Matthews, Moira Clarke, Philip Lambard and Eileen Clarke. Glen is wearing the Crown brooch given to the children for the coronation.

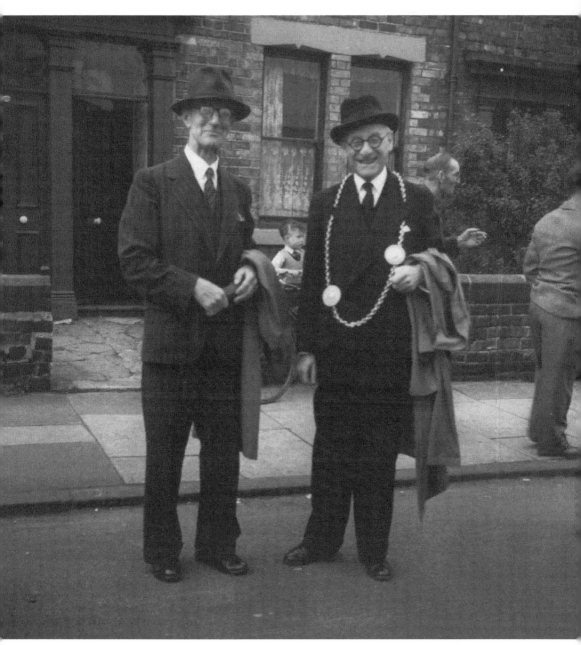

Opening the Roman Fort and Museum, Fort Street, is the Mayor Cllr A. E. Gompertz and Mr Harrison Burgess. The Roman fort was officially opened on 20 June 1953 by Sir Mortimer Wheeler, Professor of Archaeology (photograph courtesy of South Shields Library). Schoolchildren were taken on field trips to visit the Roman Fort and Museum as part of their history lessons.

In 1956 the film *Ten Commandments* was showing at the Regent Cinema, Dean Road, and at special showings in the mornings school children were taken to see it. All the children from our school had to walk to and from the cinema but it was worth it to see this epic film starring Charlton Heston. Other school visits were to the Boys' High School to see the films *Henry V* and *Richard III*.

Father Crawford, parish priest of St Bede's Roman Catholic church, introducing Lt-Col S. J. Mitton, Supreme Knight from the Knights of St Columba, who was to open the garden fate.

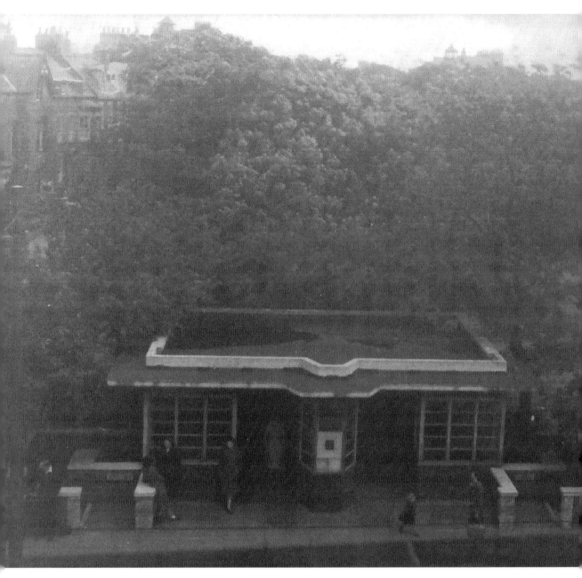

Westoe Fountain bus stop had a shelter and underground public conveniences, with Westoe Village in the background. Here we were picked up by coaches when we went on trips with the Women's Guild. (Photograph courtesy of South Shields Library)

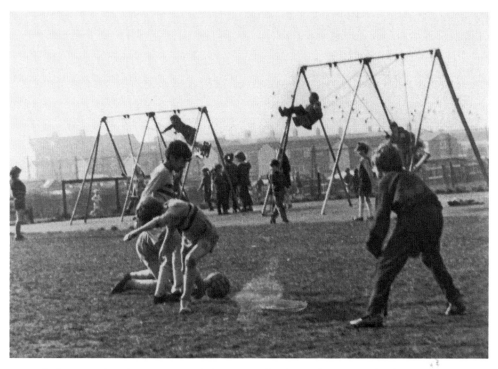

Typical playground with swings, roundabouts, witches hat and play area for football and games. (Photograph courtesy of South Shields Library)

the dell at Cleadon the boys would often take a cricket bat and collect some broken branches, so they could play cricket or sometimes football. All the parks in the town had lovely play areas.

For children playing at the hilltop there were swings to play on, a witches hat (sometimes called the teapot lid) and a roundabout, on gravel so no soft ground to fall on. If you fell you would often get gravel in your knee which had to be cleaned out – very painful.

Derby Street Baths was another place to go on the hot summer days. The baths had a green-tiled entrance hall and its large swimming hall was fitted with wooden changing stalls (neatly designed) which could be folded back against the wall when a gala was held. Seating around the pool was considered, it being a three-tiered amphitheatre. The pool ranged from 3 feet at the shallow end to 6 feet at the deep end, with a three-tiered diving board, a low spring board, a medium board and a high diving board. Many people also joined one of the swimming clubs that were held on an evening. The Westoe Ladies Swimming Club was on a Tuesday night at 6.30 p.m. and a swimming gala would be held every summer. On gala night swimmers would have to get changed in the wash house area under the baths. On the way home we would ask if there were any broken wafers at Petrozzi's biscuit factory, which was beside the bridge in Derby Street. We would then wait for the number 11 bus beside the Queen's Head public house that stood opposite the abattoir on Station Bank.

Having no television on Saturday mornings, there would be the children's Saturday

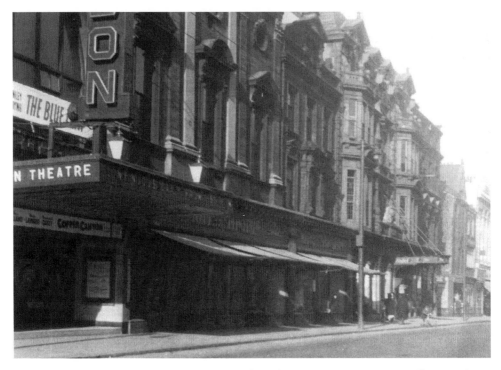

King Street entrance to the Odeon Cinema; the other entrance is in Union Alley. Marks &
Spencer is next door. (Photograph courtesy of South Shields Library)

Club at the cinemas. If you went to the Picture House on Chichester Road taking a jam jar
would get you in free, possibly because the seating downstairs was little more than wooden
forms, but if we went to the Odeon (*seen above*) in King Street we would go along to the
market afterwards and buy bags of winkles or whelks to eat on our way home.

22 September 1950 saw the opening of the Junior Road Courtesy Club; children
gathered at the police headquarters for the inaugural meeting. The club badge and
handbook was given to those children who had paid the fee and so great was the
number wishing to join, more than 3,000, that entry forms had to be given out. The
aims of the club were to exercise care as they cycled along the roads. Most schools
started cycling courses for those with bicycles. When they passed, children would be
given a certificate and badge.

During the October-week holiday many children would spend some of the time
picking blackberries, always mindful of the maggots that might be lurking in them. We
would take them home to make into jam that would last us through the winter.

Elizabeth II and Prince Philip made a visit to the region on 29 October 1954 and all the
schoolchildren were marched down to a designated place along the route to see the Royal
car pass. It was raining that morning and after what seemed like hours, the car passed so
quickly on its way to Sunderland we hardly got more than a glimpse of the queen.

Acquiring turnips for Halloween was not easy, but we would still go trick-or-treating
and hopefully get some sweets. A Guy would be made from old cloths, who would be

The National Cycling Proficiency badge was a red triangle with silver lettering and a silver cyclist on a green insert.

paraded outside the shops and pubs 'to collect a penny for the Guy' in a bid to buy fireworks. For bonfire night cardboard boxes would be collected from the shops to set up the bonfire on Blackberry Hill to burn Guy Fawkes. The boys would try buying 1*d* bangers from the shop at Horsley Hill, but as they were underage they would not be sold any and so would often try to get an adult to buy the bangers for them. Most of the street would stand and watch Guy Fawkes burn, tatties would be thrown into the bonfire to roast, flour and water would make dough and twirled around sticks, then cooked over the fire and dipped in jam to eat.

Christmas was always a time to look forward to, hanging stockings at the end of the bed and trying not to go to sleep in the hope that we would see Santa Claus. Christmas morning began by finding an apple, orange and sweets in your stocking before going downstairs to see what had been left under the Christmas tree. This would usually consist of a selection box, an annual, a game to play (something like Snakes & Ladders or Totopoly) and one year roller skates; which took a bit of getting used to. That year lots of kids got roller skates, the boys went down to Horsley Hill Square and skated – round the shops what a noise.

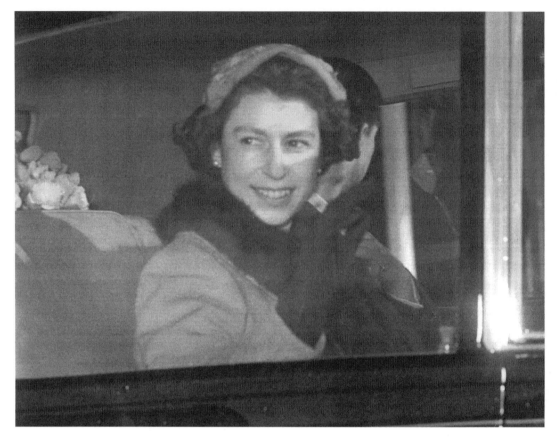

The Queen on her Royal visit to the town on 29 October 1954. (Photograph courtesy of South Shields Library)

Schools had a number of football teams. The boys would walk to Cleadon Recreation Ground (the 'Rec') for training, St Gregory's winning the Bishop's Cup in 1957. They also played cricket, winning the Primary Cricket League in 1958. The girls would play netball and rounders in the schoolyard after carrying the netball posts out of the gymnasium cupboard in the hall.

Easter was the time we would get our new clothes for the summer and on Good Friday all the children from the different church groups in the town (Brownies, Guides, Cubs, Scouts, the Boys Brigade, etc.) would march from the respective churches, except the Church of England and Catholic churches, to the old town hall in the marketplace in the procession of witness for the traditional Good Friday service. Those marching from Simonside, Biddick Hall, Brockley Whins and surrounding areas went to the West Park for their service. On Good Friday the fairground and amusement park officially opened for the summer.

At the end of the 1950s the latest teenage fashions hit South Shields and the Teddy boy with his tapered trousers, fancy waistcoat, long jacket and crepe-sole shoes would be seen hanging around beside 'Mars' corner.

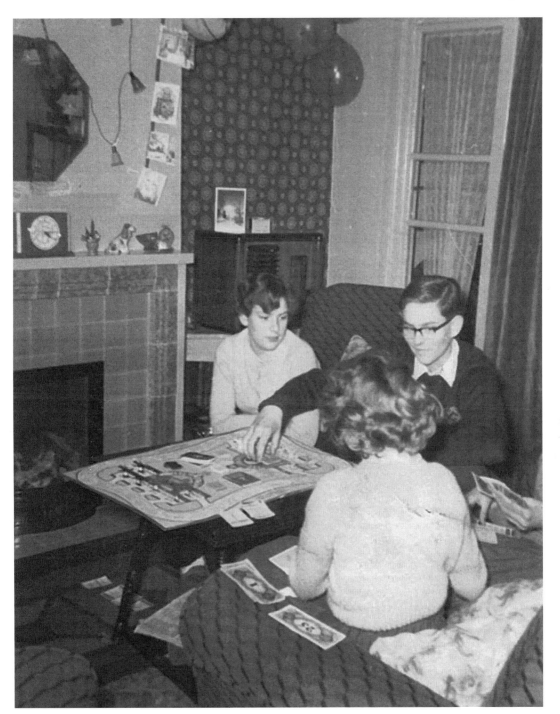

Margaret Murtaugh, Glen Matthews, Moira and Eileen Clarke playing the game Totopoly that Glen had received for Christmas.

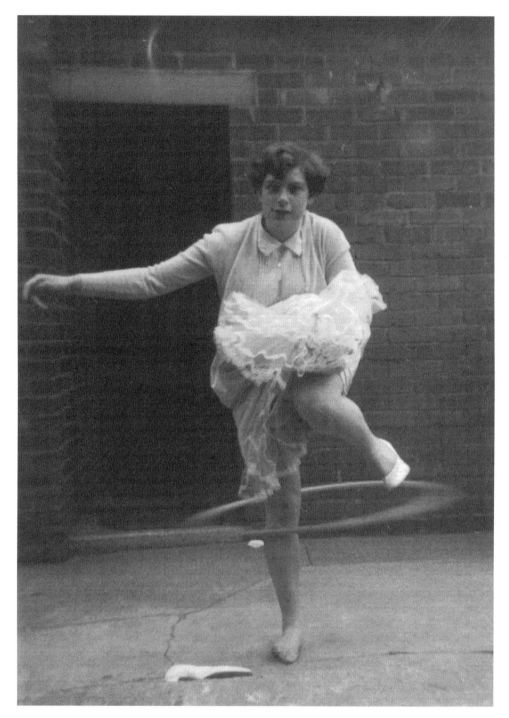

Margaret Murtaugh showing off her hula-hoop skills. This took a lot of practice as you not only had to balance on one leg but also rotate the leg to keep the hula-hoop from falling.

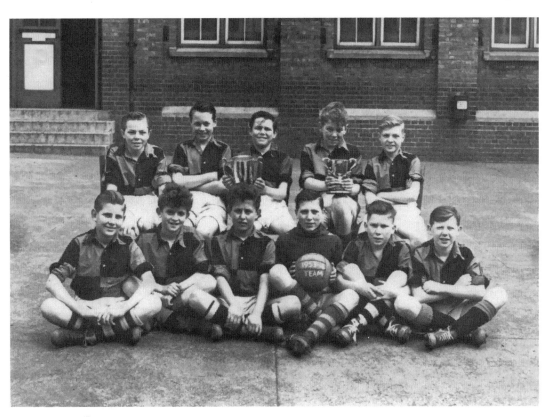

The boys of Stanhope Road Junior School football team after winning the 1954 Junior School Football Shield. The girls were the runners-up in the netball competition. (Photograph courtesy of South Shields Library)

5

Working Life

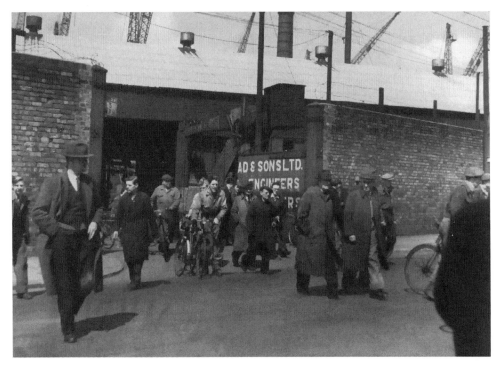

Some of the 2,000 men leaving work at Readhead & Sons Ltd. (Photograph courtesy of South Shields Library)

Looking from the ferry towards the town it is difficult to imagine that in the 1950s all you would have seen were ships, pilot boats, tugs and foy boats. The town owes much of its importance to its commanding position at the mouth of the River Tyne. Shipbuilding and the demand for coal kept the unemployment of the town quite low, with boys coming out of school into an apprenticeship in many of those industries and those that supported them. Working lives of many of the folk in South Shields meant being reliant on the river. There were many docks, wharfs and quays with their boatyards, repair yards, shipbuilding yards and timber yards, all with their many cranes

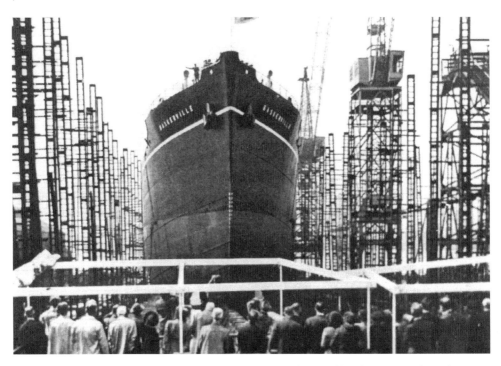

The launch of the merchant vessel *Baskerville*, built by John Readhead & Sons Ltd (yard 578) in 1954 for the Barberry Shipping Co. (Photograph courtesy of South Shields Library)

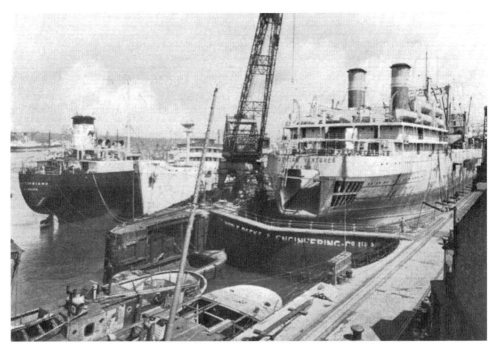

The whale-oil factory ship *Southern Venturer* (14,418 tons) in the Middle Docks for an overhaul in August 1950. These ships were a common sight on the river at this time.

stretching to the skyline, waiting to take the strain. With the shipbuilding came the establishment of engineering works, making it one of the busiest commercial centres on the coast. With vessels often lying double-berthed, it would seem that you would be able to cross the river on their decks. Tugboats and pilot boats played a vital part of river life, waiting to scurry across the river to help navigate their charges to their right berth or safely into the river or back out to sea. Shipbuilding stretched along the river from John Readhead & Sons in Temple Town to Brigham & Cowan Ltd docks in Wapping Street.

Boys leaving school going into the shipyards had a varied choice of jobs that came with a five-year apprenticeship. Blacksmiths, welders, corkers, joiners, etc., all had an Indenture of Apprenticeship Contract with the company stating their terms, conditions and wages. An apprentice joiner in the Middle Docks & Engineering Company Ltd. could expect to take home for a forty-four-hour week in 1951, 36s 6d (£1.83) in the first year, 41s 6d (£2.08) in the second year, 56s 6d (£2.83) in the third year, 66s 6d (£3.33) in the fourth year and 76s 6d (£3.83) in the fifth and last year. On completion of the apprenticeship, this would usually lead to a full-time job working forty-four hours a week or more. Each boy would have a fully skilled mentor to train him and at the end of his time was usually guaranteed a job for life. In August 1950 John Readhead & Sons Ltd had booked orders for five new ships to be built, the order being worth £2 million and one that would keep the yard busy for two years. One of the ships ordered was for Stag Line Ltd, North Shields. In September 1950 the six major shipyards, Readhead's, Thomas R. Dowson & Co., Middle Docks, Brigham & Cowan's, Tyne Dock Engineering and Anthony Proud Ltd, had a serious shortage of apprentices as boys leaving school were shunning the shipyards for higher education, with the prospect of better earnings in 'black-coated' jobs. On 14 September 1956 the new dry dock at Brigham & Cowan's was officially opened, allowing for a greater capacity for ship repair.

Besides the shipbuilding, South Shields was the largest ship-repair centre in the country. One imagines that the shipyards were always fully operational, with the noise of blasting and hammering under a permanent pall of smoke, the day being regulated by the sound of the shipyard hooter, with men in their hundreds pouring out to catch buses, on bicycles or even motorbikes, making their way home or across to the Cookson Arms in Corstorphine Town, the Commercial on the corner of West Holborn or one of the many other establishments, for lunch or at the end of the day.

The clamour of voices, the tread of heavy boots, and with the smell of paint, oil and tobacco would briefly fill the streets. Boys were less likely to follow in their father's footsteps into the tiring, dirty jobs with early morning starts. Working in frayed and blackened dungarees or trousers held up with belts, and often tied at the ankles with string and a cap on his head, was possibly not the image a boy would like to portray. Besides the orders for new ships John Readhead & Sons Ltd had on their order books, T. R. Dowson & Co. were to refit HMS *Cockatrice*, and Tyne Dock Engineering Co. were to refit HMS *Bramble*, both from the Reserve Fleet and Algerian class minesweepers. The shipyards were running at almost full capacity.

Pilots were essential to the smooth, safe running of the river. These men would be from a long line of pilots, honing the skills that had been passed down for hundreds of years in the same family. They navigated the ships in and out of the busy River Tyne, making sure they reached their correct berths safely. Many of these men would also man the lifeboats when needed. The tugboat men manoeuvred the ships by pushing or towing them on lines into their narrow berths, making sure they did not become damaged in the process. The foy boatmen also played an essential role handling the lines between the vessels and the shore or the tugboats; they would also act as an informal ferry, taking the pilots, crew and provisions to the anchored vessels in the river. The tugboat men and the foy boatmen, like the pilots, would be from a long line of boatmen whose skills would have been passed down over the centuries.

For almost 150 years coal has played a major part in the town. The first colliery was opened by Simon Temple (giving his name to Temple Town) in 1805, followed twenty years later by St Hilda's Colliery near the marketplace. Harton Colliery opened in 1844 at West Harton and Westoe Colliery in 1909 on the side of the old Bents House, the house itself being used as the offices and bath house for the miners. When the collieries were built, cottages for the workers would be built alongside to encourage men to move to the area with their families, but by the time Westoe Colliery was sunk the town had grown considerably and mostly local men filled the jobs on offer. Men worked both above ground as well as below ground and the jobs varied considerably: underground were a timberer who fashioned and installed timber supports to support the walls and ceiling in the mine; a driller, who drilled holes in the face to place dynamite or other explosives; a hewer, whose job it was to hew the rock; a collier, or a hewer, who hewed the coal with a pick; a barrow-man who transported the broken coal from the face to the wheelbarrows; a loader (also known as a bandsman) who loaded the mining carts with coal at the face; a putter (also known as a drags-man) who worked the carts around the mine; and a harrier who transported the coal carts to the surface.

Above ground there would be a brakeman operating the winding engine, a breaker boy who broke coal, and electricians and office staff of various kinds. There were also the men who worked on the mineral lines shunting the coal waggons from the various collieries to the Staiths for export. Wheels would be employed to check that the locomotives and waggon wheels were sound and the axle boxes were not getting hot. Using long wheel-tapping handles, they would hit the wheel to listen if it rang true: the good wheel would ring like a bell while one with a crack gave off a dull sound.

Although mining was one of the dirtiest and most dangerous jobs, the town collieries also had water to contend with as well as adverse geological strata, being under the sea. The pay was reasonable and many boys followed their fathers down the mine. Although at times working conditions were poor and the working environment very hot, dusty and humid, with many potential hazards and dangers, only one death, that of John Lomas, was reported in Harton Colliery up to September 1959. The comradeship and friendship of fellow workers could always be enjoyed, both in and outside work. In 1951 there were some 1,913 men working in the mining industry in the town, 1,480 below ground and 433 above ground, and by 1959 some 2,592 worked in the industry, 2,257 below ground and 335 surface workers. Harton Colliery

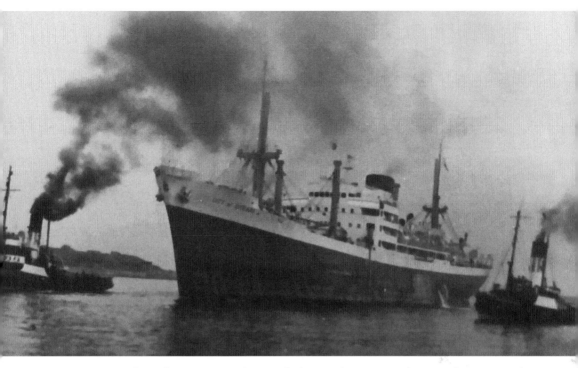

Two Tyne tugs taking the motor vessel *City of Chicago* downriver. (Photograph courtesy of South Shields Library)

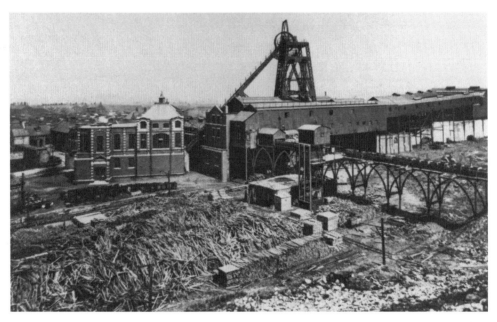

Harton Colliery was the biggest employer of colliery workers in the town with a total of 1,430 men working either below or above ground. In October 1950 they exceeded their target of 8,000 tons of coal, producing 9,398 tons. Westoe also exceeded their target by producing 2,750 tons (their target was 2,000 tons). (Photograph courtesy of South Shields Library)

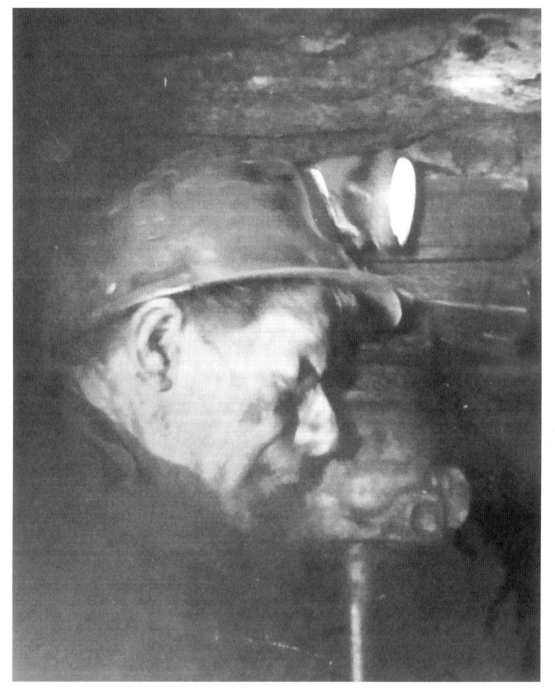

Underground at Harton Colliery a miner is working at the coalface. (Photograph courtesy of South Shields Library)

was the largest employer but by the end of the decade numbers were decreasing while at Westoe Colliery numbers were increasing.

Coal-trimmers worked in dangerous conditions, trimming the coal that was being poured into the hold of a collier. As the coal was tipped into the hold the trimmer had to level the coal, working very quickly to make sure he moved up as well as sideways so he was not trapped beneath the deck. Most trimmers worked for the Staiths Master and not the colliery.

Ironfounders, making all classes of ship castings, ship propellers and castings for all types of oil engines, employed quite a number of men in their Corstorphine town works. Here a bucket of molten metal is being poured over casting moulds. This takes place outside in the yard where the workmen have to guide the buckets that are attached to crane. This could be a very dangerous job. First the men would have to load the furnace from the top with ironstone, charcoal and limestone, which acted as a flux to make the molten iron run easily like a liquid. This liquid state is then run off into large buckets which are used to carry the molten iron to the moulds. Tillers were employed to load the furnaces with the correct quantity of material. This job could also be very dangerous. The founder was the man in charge of the overall operation of

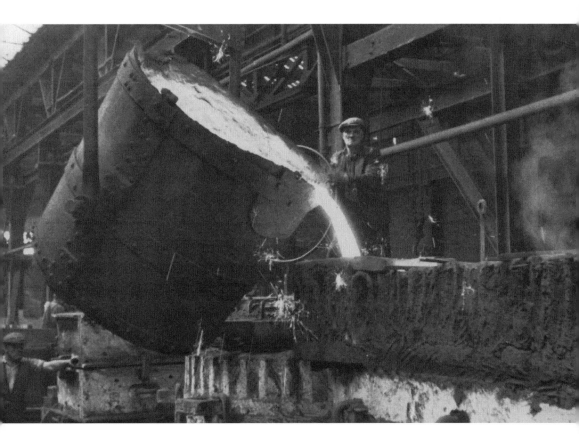

Charles W. Taylor & Son Ltd, iron founders, Commercial Road. (Photograph courtesy of South Shields Library)

the furnace and responsible for the quality of the iron produced. The pattern-makers, as their name suggests, made the moulds into which the metal was poured. The finer had to ensure the furnace temperature and strength of the air blasting was sufficient to produce the highest quality product. In a similar way the hammer man needed to know what combination of temperature and hammer size would produce the correct amount of compression for the size and shape of the product required.

This was dangerous work. The foundry melts brass and copper down to liquid and the hot metal was poured from the furnace flask into the moulds (the hollow forms in which the cast is made) to make parts. As the men did not wear any special clothing, if the flask or mould slipped they could receive severe burns. Part of the founder's job was melting and pouring, and part was making the moulds which were not easily made. Another part was making the sand moulds around the forms and part was grinding and polishing the pieces as they came out of the moulds. Brass moulders and coppersmiths would normally serve an apprenticeship of five years. In 1950 a new extension was built, which increased the workforce by between 200 to 300 craftsmen, bringing the total to around 600.

Many girls leaving school hoped to go into office work, going to college to learn shorthand and typing or bookkeeping. Some would be lucky and start as an office junior, but for many others it would mean shop work or the factories. Wright's Biscuit factory employed girls on shift work. Wages for a girl of sixteen years was 11¾d (5p) an hour, at seventeen years 1/o pence (just over 5p) an hour and at 18 years 1/5 pence (8p) an hour; this would be for a 40- to 45-hour week.

Morganite Resistors was a manufacturer of electronic components for the electrical and electronics industry. It supplied resistors and large surge diverters as well as insulators for the electrical-power industries. Located on the new Bede Trading Estate at Simonside, it was a large employer of women as well as men in the factory. It also provided a useful training facility for students studying electronics or electrical engineering at college as they would employ them for the summer break, giving them valuable industrial experience. The students would be employed either in the test or manufacturing departments of the factory. Women at the factory worked mainly on the shop floor as machine operators on a variety of machines doing various jobs in the production process. All the women were on piece-work rules and could be very vocal of their criticism of the poor students working there if the machines were not fixed quickly to get production going again. The register-sorting machines they worked were a constant source of trouble as they worked at a fast pace determined by the women moving components rapidly onto the various sorting machines, and because they were paid by the number of components tested each day they would try and push too many into the machines causing them to break down. Morganite Resistors was at its height in production in the 1950s but as foreign competition started to flood the market, they eventually closed in the 1980s.

S. Newman's new modern factory in Commercial Road was opened in September 1954 and was the home of Slenderella lingerie and slumber wear. They employed 175 young women who turned out over 10,000 garments each week – filmy lingerie, nightdresses and pyjamas, both for local and international markets including the

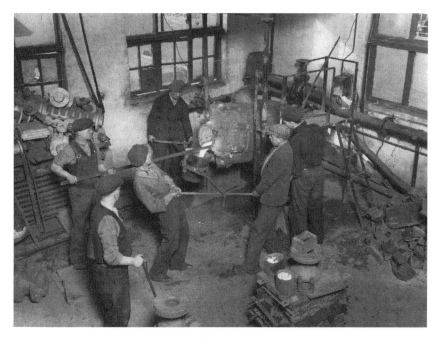

Men working in the casting shop of Peter Johnson & Co. Ltd, brass founders, coppersmiths and engineering contractors. The man to the left is guiding the hot metal out of the furnace while three are holding the flask or mould. (Photograph courtesy of South Shields Museum & Art Gallery)

A typewriter used in most offices. These had to be mastered: girls would be expected to be able to type at least eighty words per minute. A personal secretary would be expected to be able to type 100 words per minute if she was to keep her job. Most of the big firms in the town employed typists to some degree or another, from the shipping industries to the big stores. Even some smaller firms would have office staff.

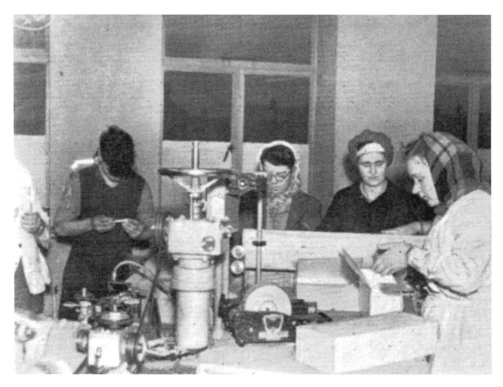

Staff working in the Morganite Resistors factory on the Bede Trading Estate.

Bahamas, South Africa, Jamaica and Scandinavia. Mary Harris Ltd, John Clay Street, made exclusive gowns in their modern factory with the most modern machinery and equipment, and made clothes for Marks & Spencer. Both these firms, along with Eskimo slipper factory in Taylor Street, Price's and John Collier's, employed hundreds of young girls as skilled machinists.

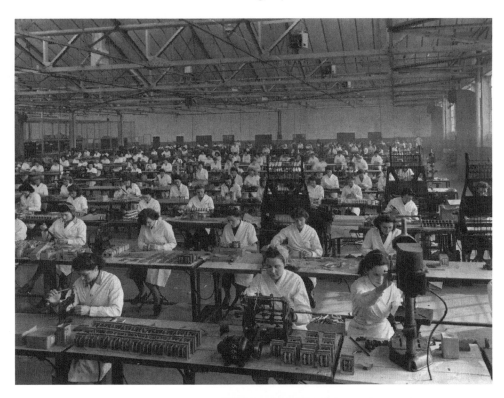

These girls are working in the factory of Wright & Weaire Ltd, at their Simonside works, making electrical products such as transformers, vibrators, chokes, switches and coils. The work was very repetitive and sometimes boring, but as they were on 'piece time' the wages could be very good. In 1958 the company changed their name to Ferrograph Co. Ltd. (Photograph courtesy of South Shields Museum & Art Gallery)

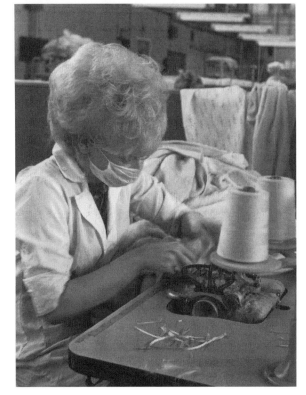

A machine worker at S. Newman's making garments for the Slenderella range. (Photograph courtesy of South Shields Library)

6

Days and Nights Out

Wednesday 7 June 1950 saw South Shields sweltering: the temperature at 10.00 a.m. smashed its previous record and reaching 78° Fahrenheit (25° Celsius) climbing to 80° in the afternoon. This was the highest temperature recorded since the town's weather recording station opened sixty-six years earlier. Early closing was on Wednesdays at 1.00 p.m., and Tyneside folk, eager to take advantage of the scorching sun, rushed to

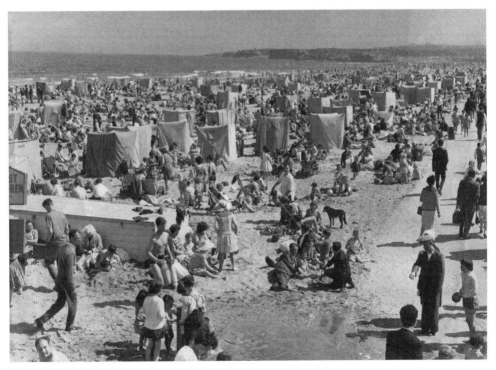

A view of the South Beach, looking towards Trow Rocks with Marsden Bay and the Marine Grotto in the far distance. A typical summer's day, the beach crowded with locals and holidaymakers looking for a space to sit between the tents. (Photograph courtesy of South Shields Library)

the coast to take advantage of the gentle south-westerly breeze to bask in the heat. As the day progressed ferries trains and buses became crowded as more people headed for the coast. It was a day that saw mineral water and ice-cream vendors doing a brisk trade as the many visitors tried to quench their thirst and seek refuge in the sea from the scorching heat. Many visitors headed for the amusement park, which gave the entertainment vendors a day often only dreamed of as the previous week the sands and amusement park had been all but deserted as the weather had been cold with north-easterly winds.

South Shields was rapidly growing as a holiday resort and the town had much to offer with its attractive bays, cliffs and coves, golden sands and an amusement park. The Pier, which is a mile long, was also a great attraction, not only for strolling along but for fisherman. Both the North and South Marine Parks held their own attractions. People flocked to the beaches in South Shields, some coming by specially hired buses from as far away as West Stanley. With the South Promenade being opened to light traffic, the construction of new car parks allowed coaches to park close to the beach area. Some visitors would simply catch a local bus, others came via the ferry from North Shields to Ferry Street and the Market, walking up King Street and along Ocean Road. A great number would come by train to the station in Mile End Road.

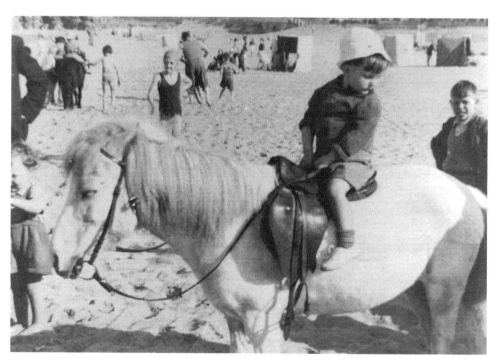

The North Sands with a child riding a donkey – very popular with both adults and children. You would also find the shuggy boats (swinging boats in which riders, sometimes as many as six, pull ropes to swing back and forth): the harder you pulled the higher it went, with the men pulling as hard as they could to make the girls and women scream. (Photograph courtesy of South Shields Library)

The North Marine Park, a delightful place for recreation and rest, was created by levelling part of the ballast hills. These were created by the tipping of ballast from the ships entering the Tyne from all over the world; this needed to be discharged before being refilled with goods such as salt and glass, for the merchants to sell to other countries and coal for shipping down south. Unfortunately, while laying out the park, they destroyed, at its northerly end, a Roman well originally known as the Hog's Head Well, which had been described as 'a picturesque feature arched with moss covered stone'. The park had many pleasant tree-lined walks, one of which ran beneath a stone arch, the stone of which was possibly some of the original ballast. Tennis courts and five bowling greens were at the beach side of the park, and there was also a small putting green to entertain the family. At its highest point was the Marine College's Radar Training Station. The view from there was well worth the uphill walk, looking over to Tynemouth in the north to Marsden Bay in the south and, if you got thirsty, you had a choice of three drinking establishments, the Lookout, the Crown and the Beacon. A playground for children could also be found there. In 1953 the park was registered under the Historic and Ancient Monuments Act as being a park of historic interest. In the park there was also a bandstand where you would be able to hear a different brass band each Sunday at 3 o'clock.

The South Marine Park, on the other side of Ocean Road, was more popular for those wishing a more leisurely stroll along formal paths. Ornate balustrades marked different tiers, with a pleasant waterfall at the top end of the park. Like the North Marine Park on most Sundays in the summer, at 3 o'clock and 8 o'clock you could take a seat on the terraced area above the bandstand and enjoy a few hours of musical entertainment by the area's many brass bands. A large lawned area sloped towards the lake where you could spread out for a picnic or just sit, enjoying the sun. On the lake you could hire a scooter boat; the lake was also used for sailing small model craft by members of the Yachting Club and model enthusiasts. A tea room was also near the lake for those wishing for a nice cup of tea, coffee or an ice-cream.

For the children, at the Pier Head, there was a miniature railway where they could ride on a train drawn by a true-scaled model of the *Coronation Scot*. The Pleasure Park, with its many attractions, was always a pull for the adults as well as the children with its special delight, the Kiddies Corner and the Ghost Train, a favourite of the courting couple. The Helter Skelter, with its cork mats for you to sit on to go down and round, getting faster as you go, was surprisingly very popular. The Figure of Eight, with its fast-running cars going round high above the ground; the Wurlitzer, spinning you round and back; Swinging Chairs revolving you up and out; Dodgem Cars with fast-moving cars all trying to avoided each other, always drew large crowds. One of the favourite attractions was the Laughing Sailor, which that stood at the entrance of the Amusement Arcade. Jolly Jack attracted many people when he started to laugh. All you had to do was put a penny in the slot and he started laughing and before he finished he would have attracted a large crowd who would also be laughing at his antics. Inside the arcade you could find all kinds of penny slot machines, some for a 1d and others for 6d (just over 2p).

The South Beach, being much larger than the North Beach, had a promenade

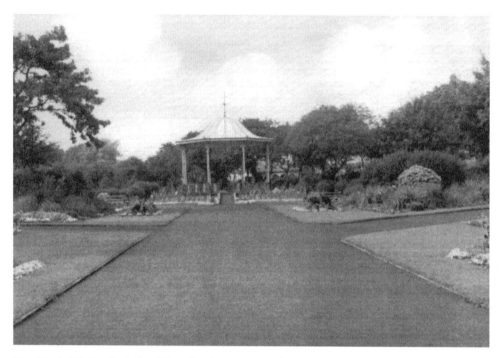

The North Marine Park Band Stand, where on a Sunday you could sit and listen to such bands as St Hilda's Colliery Band, Harton Colliery Band or Easington Colliery Band. (Photograph courtesy of South Shields Library)

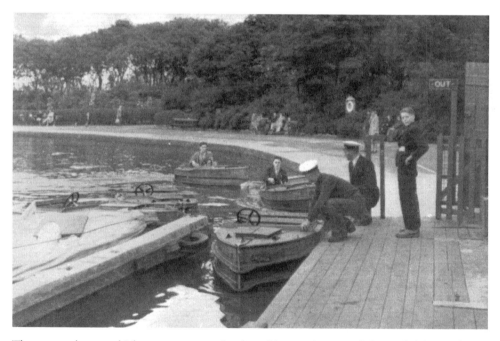

The scooter boats, which were very popular for taking a trip around the park lake, with two smartly dress attendants with sailor caps organising the loading and unloading of pleasure-seekers on the lake.

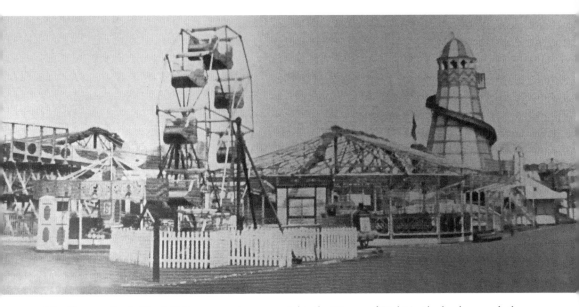

The Pleasure Park. The kiddies corner is centre-right, the Figure of Eight in the background, the Wurlitzer to the left of the kiddies corner, the Helter Skelter behind and the Swinging Chairs in the background.

stretching its entire length; ornate balustrades went from the Amusement Arcade to the visitors' chalets which could be hired. Although the South Beach was much larger you still needed to get there early if you wanted a good spot to pitch your tent as the beach filled up fast. Tents could be hired for 2/6d (just over 12p) with a deposit of 2/6, and deckchairs were 9d. Mothers with very small children and/or babies in prams would be seen pulling those prams across the sand looking for a good spot to set down the blanket or tent, if they had hired one. Tickets could be bought from the small kiosks for trips on Mitchelson's pleasure boats which always proved popular, with a choice of destinations: around the harbour or down the coast and when the tide was rightout – under Marsden Rock arch.

There were a number of cafés for refreshments. Coleman's Café was one of many open for a meal or refreshment and the Wouldhave Civic Restaurant, with a seating capacity of 160 that would cater for meals at most times in a modern and attractive dining room, was only a few yards along the South Promenade. Frankie's had three cafés – the Northern Café beside the North Promenade, the Ritz Café and the Café Carlton both of which accommodated 200, on the South Promenade, Mowbray Road end – where you could get hot water for your tea, fish and chips, pies or a meal inside. If you liked eating on the beach you were more than welcome. Frankie's famous ices had also won a diploma of merit in 1953 at Olympia in London.

There was always plenty to see and do: taking the cliff path from the end of the promenade, the bay at Trow Rocks was another popular place for youngsters to go swimming or just sitting watching others brave the cold North Sea. Walking along the cliffs, one distraction for walkers was the dock gate, which was wrecked in high seas

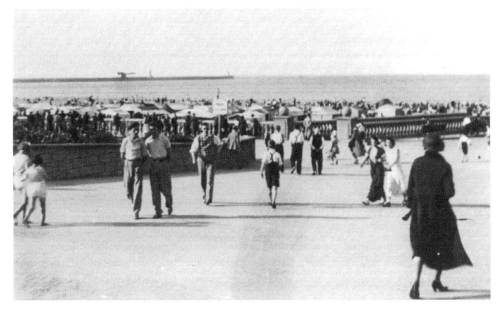

The Promenade beside the South Beach showing the ornate Balustrades that ran most of the way along the beach with the pier in the background.

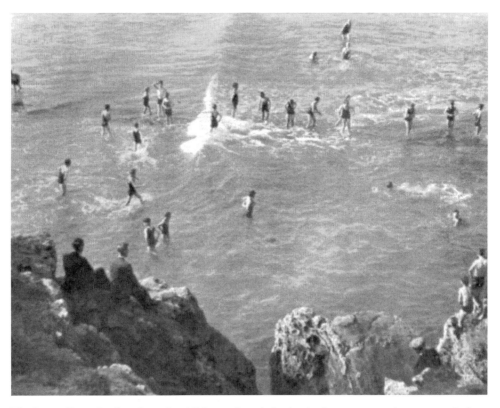

The bay at Trow Rocks where the children enjoyed playing in the water on a hot summer's day.

off Trow Rocks towards the end of the First World War. As the gate was being towed off the mouth of the Tyne it broke its moorings and foundered on the rocks and can still be seen today. There were also the gun emplacements still along the path which the children liked to play on. With the many miles of cliff walks, passing some pretty little coves such as Frenchman's Bay, accessible by a rickety ladder once used by fishermen, you headed towards the Velvet Beds at Marsden Bay, with the Marine Grotto close at hand.

The Velvet Beds at Marsden Bay were accessible either by the cliff path down by 'Camel's Island' from the cliff walk or by the steps down from Redwell Lane bank. Marsden, like the town beaches, not only attracted the locals but many holidaymakers and day trippers. At the bottom of the long flight of steps was a café that also hired out deckchairs and tents: deckchairs were 9*d* with 9*d* deposit (around 4p) and tents were 2/6*d* with a deposit of 2/6 (just over 12p) and gave you hot water for a small charge. There were also toilets and first aid facilities. Then you descended another short flight of steps to the beach. Like the town beaches, if you wanted a good spot you needed to get there as early as six o'clock in the morning to get a tent, even though they did not open until around nine o'clock. It would get very crowded by midday. At the far end of Marsden beach was the Marine Grotto public house and the rugged, windswept and weather-beaten Marsden Rock, home to one of the most interesting bird colonies in the area. This 100-foot (30.48 metres) rock is one of the town's main attractions. The rock stood around 100 yards (91 metres) away from the Marine Grotto public house and became a breeding ground for cormorants and kittiwakes. A few herring gulls also joined the community which included puffins at one time. These were a great attraction for many sightseers.

The Marine Grotto was a very popular place for refreshments, a most unique public house formed from caves in the rocks. Once the home of 'Jack the Blaster', it was taken over by Peter Allan junior who turned it into a public house in the early 1800s. It had a public bar in a cavern to the north of the terrace, a larger cave lounge, and a modern grill room built above these caverns which led to a small cocktail bar. For those coming from Whitburn and wanting to access the beach more quickly than descending the 119 twisting steps to the terrace, a lift, taking forty seconds, had been installed to make the Marine Grotto more accessible.

In 1950, the town had twelve cinemas, most of them in the centre of town. The Odeon in King Street, whose main entrance was in Union Alley behind King Street, would hold pantomimes there at Christmas, and some local firms, like James Quigley, would book a Saturday matinée for the children of their employees. It would also host International *All-Star Variety Shows* at other times with shows starting at 6.25 p.m. and 8.40 p.m. The Savoy in Ocean Road, which was the largest in town with a seating capacity of more than 1,700, was the epitome of luxury for cinemagoers. When, in 1955, the *Dam Busters* was shown the queue was round the block and special buses waited along Ocean Road to take cinemagoers home. The Scala Cinema, later the Gaumont, in Mile End Road, had a second entrance in Ocean Road for the circle seats, where there was often the aroma of exotic confectionary, showed films like *Oh You Beautiful Doll*, a technicolour film based on the life of Fred Fisher, starring Jane Haver and Mark Stevens, with *Mother Didn't Tell Me* the supporting film, starring Dorothy

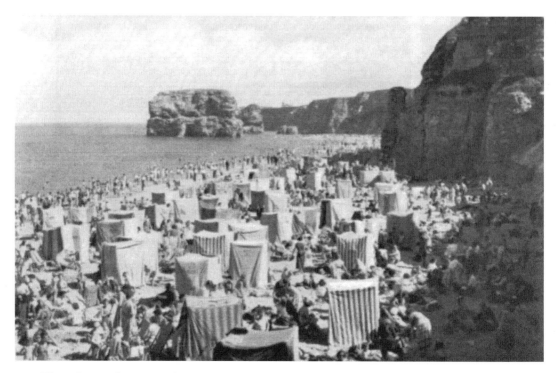

The Velvet Beds at Marsden Bay were just as popular as the town beaches although more sheltered by the cliffs.

One of Mitchelson's pleasure boats giving passengers a trip under Marsden Grotto at high tide. This was the only time they could do this as at low tide the sea was too shallow. (Photograph courtesy of D. & A. Harris)

McQuire. Most areas had their own cinemas. The Palladium at the Nook, purpose built and which could hold almost a 1,000 people, drew its audience from the growing communities in the areas of Marsden and Cleadon. The Picture House in Ocean Road, the Pavilion in Derby Street, the Plaza in James Mather Terrace, the Regent at Westoe, the Westoe Picture House in Chichester Road and the Imperial off Stanhope Road and the Crown at Tyne Dock all showed popular films and also saw long queues on a Saturday night.

By 1959 more people were buying televisions and the cinema was becoming less popular: five had closed down – the Pavilion in Derby Street, the Plaza in James Mather Terrace, the Crown in Hudson Street, the Imperial Picture House Farnham Road and the Westoe Picture House in Chichester Road.

Dancing was becoming one of the more popular pastimes with plenty of dance halls in the town to choose from. The Majestic Hall stood at the eastern end of Ocean Road on Pier Parade. Although this was a purpose-built ballroom for both modern and old-time dancing, the floor was not that good to dance on. Dancing in the evening was from 7.30 p.m. to 11.00 p.m. for both modern and ballroom dancing. You could also go to one of the tea dances that were held every day in the afternoon from 3.00 p.m. to 5.00 p.m. George's School of Dancing, on Law Road, was run by two brothers and was popular on a Friday and Saturday night. The Golden Slipper Club, run by Alf Josephs and his band, was held in the Hedworth Hall on a Saturday night. The Crown

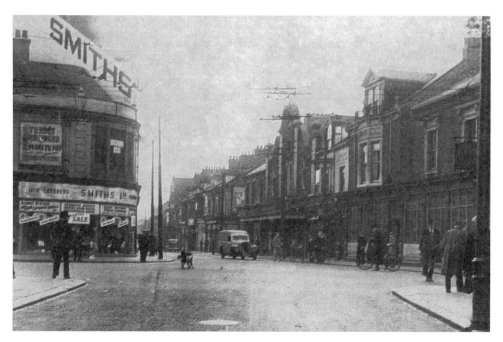

The Palace in Frederick Street was one of the older picture houses that saw capacity crowds at a weekend. It was like most of the cinemas in the town as you would have to queue early on a Saturday night to get to see your show. It played films like *Lust for Gold* starring Glen Ford, which was a story of the fabulous lost Dutchman Gold Mine in Arizona.

Assembly Hall, with the Crown Billiard Hall in the same building, was on the corner of Ocean Road and John Street. With a perfect dance floor and a first-class band, it had a delightful atmosphere for dancing, both modern and old time. On wet days the billiard hall, with its twenty tables, was ideal and women were more than welcome.

The Regent Hotel catered for all types of clientele – visitors, commercial travellers and local people who just wanted to pop in for luncheons, afternoon tea or an evening meal. The Regent Hotel became the Dorset Café in Ocean Road. The Dorset Café, like the Regent Hotel, was a very popular meeting place for both morning and afternoon tea. Open daily from 9.00 a.m. until 10.00 p.m. and on Sundays from 6.30 p.m. to 10.00 p.m., the Dorset Café catered for all occasions. In 1951 special luncheons cost 1/6d (just over 7p) to 1/9d (just over 9p) for three- and four-course meals with afternoon tea 1/- (5p), 1/4d (7p) and 1/6d (just over 7p). Reception rooms were available for both parties and outings. The Dorset Café also catered for weddings, with buffet meals from 4/6d (just over 22p) a head.

The Pier Pavilion was a charming cosy little theatre where the best dramas and latest comedies frequently provided light entertainment. There were also musicals by first-class companies at moderate prices of 12/6d. Originally built as a shelter, the sides were enclosed and it became a theatre. In 1956 the Gilbert & Sullivan Amateur Drama Group presented two shows a year – in April and October. Sunday was the dress rehearsal, which ran from 9.30 a.m. until midnight, and the cast had to provide their own music. Monday night was for the dignitaries of the town, including the mayor and mayoress. The cast called them 'the sit on hands audience' as they very rarely clapped. Shows started at 7.30 p.m. each night with Wednesday and Saturday 2.30 p.m. matinées.

South Shields Greyhound Stadium was a popular night out for the men and sometimes the women in the town. 'Greyhound Tips' by Kennel Boy was a regular feature in the *Gazette*. Kennel Boy kept the punters up to date with the latest gossip about the runners and the likely betting odds for each dog. Many of the greyhounds were locally trained and betting on them was fierce as the trainers were well known by the punters. Many of the trainers would be seen training their greyhounds on the beach and many punters would time their performances. In 1950 Glenfield Willie and King's Invader were two of the favourite dogs to be running at the track.

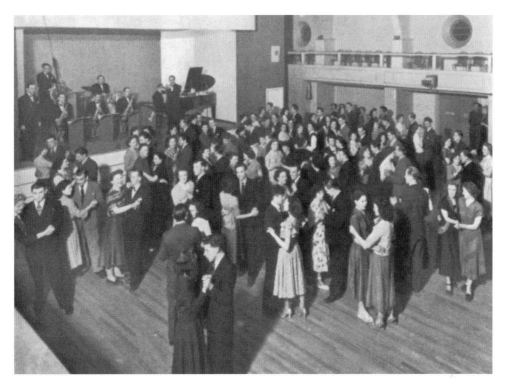

The Majestic Ballroom where you could enjoy an afternoon tea dance or an evening of modern and ballroom dancing to a resident band. The Majestic also had a modern snack bar and catered for lunch parties.

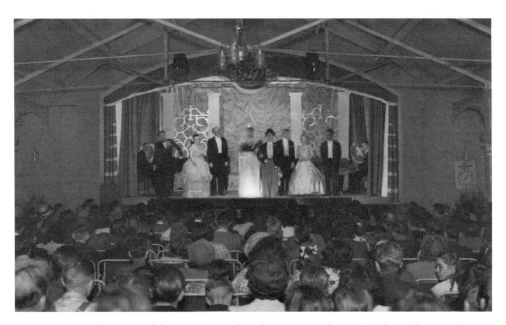

An audience watching one of the many musical performances at the Pier Pavilion. (Photograph courtesy of South Shields Library)

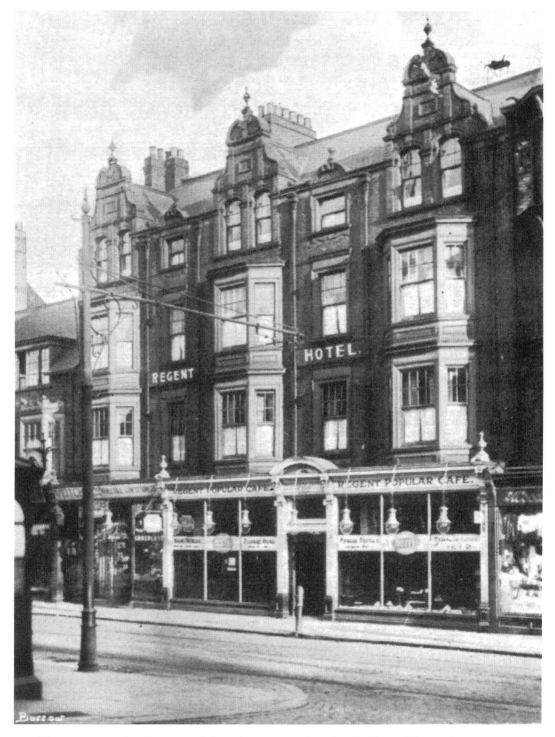

The Regent Hotel in Ocean Road, later the Dorset Café and today the Halifax Bank.

The Donkey Derby was an annual event that took place every June during Tyneside's annual race week holiday at the Greyhound Stadium, Horsley Hill Road. Many famous jockeys would take part in this event which drew big crowds. (Photograph courtesy of *South Shields Gazette*)

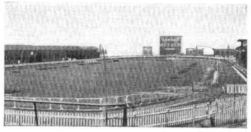

A ticket to the races.

The Shops & Market

South Shields was a vibrant shopping area, despite the destruction caused by the war. Not only was there town-centre shopping but also local shopping areas and punters would go 'down town' on a Saturday for something special.

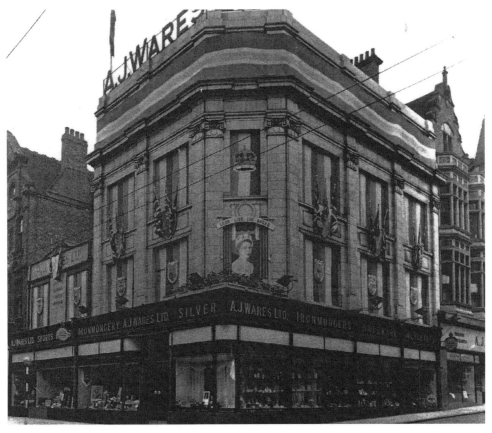

A. J. Wares Ltd, hardware merchants, ironmongers, silverware and sportsware store. The store is decorated for the coronation of Elizabeth II. (Photograph courtesy of South Shields Library)

Laygate was a very popular shopping area catering for all tastes. Arthur Pierce, opticians, was beside the Adam & Eve public house. Brown & Hall, drapery store which was well worth a visit, was just across the road with G. Law, paint and varnish merchants, next door. There were two bicycle shops; Harmer's was near the Co-operative Store and Harrison's near Reed Street, so if one did not have what you needed the other possibly would. The Jarrow & Hebburn Co-operative Store, selling their own branded groceries as well as furniture, hardware, radios and cutlery, was also there.

Hamond's Remnant Shop sold wonderful material for making clothes and furnishings. You did not have to wait for the sales to bag a bargain. Their stock mainly consisted of manufacturers' faults and remnants, buying at a low price and selling at a bargin price to customers. Flannelette for nightdresses, satins for lingerie, cotton prints for dresses and skirts, poplins for blouses, woollens for warm winter coats and velvets for dresses and curtains were all available. Many a doll was dressed with patches from the Remnant shop as it was more popularly known. Shane's Fashions ,for the latest fashions in ladies' wear, was very popular as prices that were always reasonable. Fyfe's and Paul Vassallo's, fishmonger shops, sold fresh fish that was in season. Kippers were popular for breakfast, as were dressed crabs for 1/6d (around 7p). Fishers Bros, pork butchers, was a favourite for their pork sandwiches with stuffing, crackling dipped in

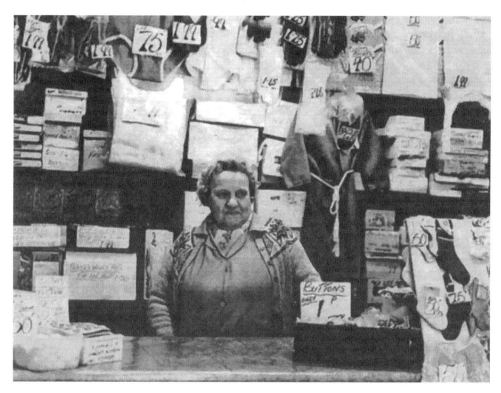

Axelbands sold everything from babywear to grandma's corsets and bloomers, and men's braces, hatpins, winter vests, libity bodices and mens' long johns – an Aladdin's cave of essential undergarments for everyday use.

sage and onion gravy or a savaloy dip with pease pudding dipped in gravy. At Phinn's the butchers you could get pigs' trotters and sheeps' heads. If you needed anything reupholstered Mackay's Furnishers was the place to go. You could get a three-piece suite reupholstered or renovated. Mackay's also supplied parts to make your own furniture, say a coffee table, and the tools to make them with: everything for the handyman. Hunter's was renowned for their good hard-wearing footwear, with a reputation for an efficient friendly service. Hunter's shoe shop sold a wide range of footwear from workboots to slippers, fur booties for girls standing on factory floors or who walked a lot, to a good stock of children's slippers, fashioned in coloured felts or shaped like cute elephants, ducks or rabbits, which were suitable to put away for Christmas. Clark's was the place to go for the latest in prams – Silver Cross, Pedigree or Marmet – as well as baby toys. It also had a good selection of Tri-ang, Dinky, Mobo and other leading makes.

This was a busy thoroughfare leading to the market place that had its own wide variety of shops. Among the stores was Frank. R. Moat, butcher's shop, and J. & M. Ireland, newsagents. Further down was E. C. Watson, a beer retailer, McAdams Ltd, selling readymade as well as made-to-measure suit and coats, with Gatoff Outfitters just along the road. D. West, greengrocer's shop, was on the corner of Green Street and Victoria Road with its advert for 'Batchelor's Baked Beans' across the top of the window and its whitewashed prices – oranges six for 1s, (5p), sweet grapes 1/6d, (around 7p), etc. On the opposite corner, Cuthbert Street, there was Barrett's. There was also Newton's pork butcher, with that lovely smell of pork pies just out of the oven, Cromwell's Furnishers, and two leather merchants, Joseph Armstrong Ltd and Tyneside Leathercrafts Ltd plus Norman's Bargain Store. Tyneside Leathercrafts Ltd supplied a wide variety of leatherwear for miners – kneepads and belts, as well as back protectors, aprons and collector's bags for professional use, leather and canvas bags including shopping bags, school satchels, cycle bags, rucksacks and haversacks.

Allen & Co. (South Shields) Ltd, known simply as Allen's, had three stores in the town, two at Laygate; one on the corner of Laygate Lane and Adelaide Street and the other across the road on the corner of John Williamson Street, the third at the Nook. In 1956 Allen's celebrated its 100 years of service to the town. They sold almost everything at a reasonable price: soft furnishings; furniture draperies; ladies' gowns; Slenderella ladies' underwear, manufactured in the town; dress material; millinery; mantles; Castle Wear men's ready-to-wear clothing; fancy goods; boots and shoes; and wallpaper and paint. Allen's also had their own coinage, which would be given instead of change. This ranged from 1d to 10s (less than 1p to 50p). Smith's Ltd, furniture store, on the corner of Frederick Street and Laygate Lane, sold modern furniture. In 1950 a bedroom suite in figured oak, designed on the latest lines, was only 44 guineas (£46 10p) or 9s (45p) a week. Next door was the Laygate fruit store. Going towards High Shields, Swainton's confectioners sold a great variety of sweets. Harry Wilkinson's corner shop was were old comics could be swapped for ones you hadn't read. Welch Potts, butcher's, was at the High Shields end of Laygate and Vasey's fresh fish shop was opposite the Zion Hall. Walking up Laygate Lane towards Chichester there was a variety of small shops. Moore's Stores was just up from Laygate fruit stores, Tailford's, upholsters, on the

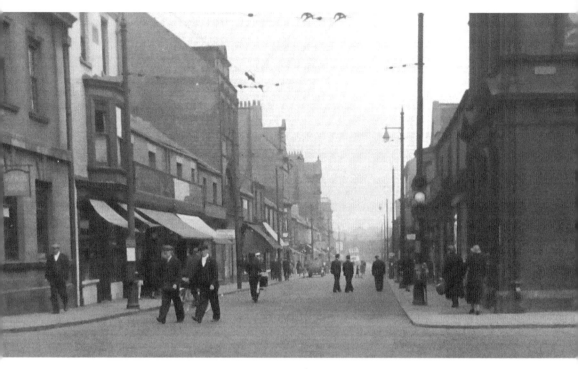

Green Street looking towards Cuthbert Street with Lloyds bank on the left and Martin's Bank on the right. (Photograph courtesy of South Shields Library)

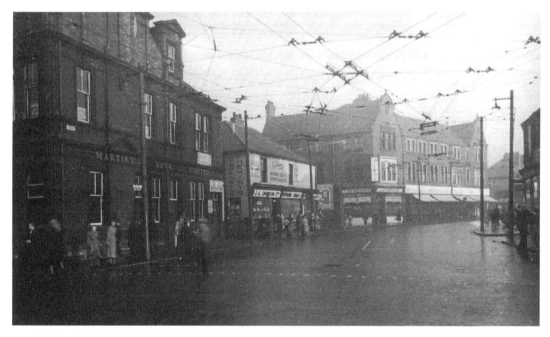

Laygate Lane. Martin's Bank is on the corner of Green Street with J. G. Dawson Ltd, chemist, and Harton Cleaners on the corner of Adelaide Street and Lawrenson's butchers on the opposite corner with Allen and Co. Ltd, who later took them over. (Photograph courtesy of South Shields Library)

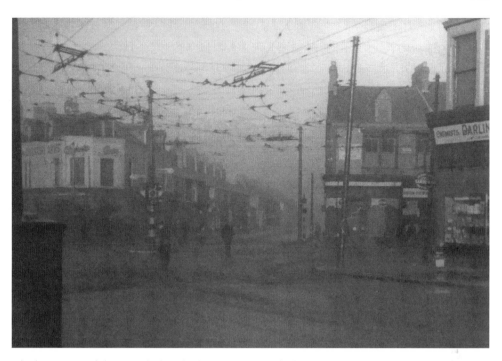

Chichester roundabout with the Chichester Arms public house, James Quigley greengrocer's and flower shop and Darlings the chemist on the corner of Dean Road and Stanhope Road East. (Photograph courtesy of South Shields Library)

corner of Princes Street, Clark's florists with their beautiful array of coloured flowers for all occasions, Hall's Shoe Repair's, on the corner of Laygate Lane and Eglesfield Road, Metcalfe's wallpaper store on the corner of Alice Street with Hanson's fish and chip shop on the other corner and the pet shop opposite the bus stop at Chichester, just down from the Chichester Arms public house.

Chichester was another busy area with its own shops. Stanhope Road East had its own parade of shops including Harris's newsagents and Dandy's dry cleaners, whose advert was to 'spend shillings to save pounds and have your costumes, coats and dresses dyed in one of our twenty-five new shades from 8s (40p) instead of paying pounds on new clothes'. Hanlon's grocery store, on the corner of Northcote Street; McKiernana, fashion showrooms, which sold Stylebridge coats with prices ranging from £5 19s (£5 95p); and the post office, which was next door. In Dean Road, beside Quigley's, was Tisseman's watch and clockmakers; Harris's tobacconists; Boal's the fishmongers; the Jarrow & Hebburn Co-operative Store on the corner of Milton Street selling their own brands of groceries. Then T. W. Holdsworth who sold the latest models in radios and televisions including Ekco, G. E. C. Marconi and Ever-Ready, as well as a comprehensive range of electrical appliances. They also sold and repaired bicycles and tricycles in the shop. Frank Lake's, ironmongers, selling all manner of household goods; Ingham's butchers; Blackburn's boot and shoe retailer and repairers; the Spot Cash Bakery Ltd that always made your mouth water as you passed. Besides cakes and bread it sold 1*d*

uncut miniature Hovis loaves. John Brown's fruit shop; a newsagent on the corner of John Clay Street; and, round the corner in John Clay Street, Billy Blythman's butcher shop, which had rabbits and joints of meat hanging in the window and smaller cuts laid out on the marble window. The half-carcasses would hang on hooks at the back of the shop. On the opposite corner of John Clay Street was Harton cleaners and dyers, where they would starch the collars of men's shirts for a fee. At the top of Dean Road was Westoe nurseries, for those special-occasion flowers, and John W. Pratt, a wine and spirit merchant.

There was Brown's the drapers, Little's grocery store, Bennington's dairies who supplied pasteurised, sterilised and T. T. farm-bottled milk, Bullock's shoe shop, for all our school shoes, winter boots and fashonable footwear, men's Oxford shoes and ladies Stroller shoes with heavy crepe soles, and further along next to the post office was A. D. Sayer's fruit shop with H. A. Johnson next door, one of two butchers. Next door to Johnson's was Hartley's fruit and vegetable shop before you came to the Jarrow & Hebburn Co-operative Store on the corner of Sunderland Road. Just round the corner in Sunderland Road was J. A. Neeson, baker and confectioner, with their tempting array of cakes and biscuits, with the Nook fruit store next to them. On the other side of Sunderland Road was Martin's bank and J. Stolliday's grocery store where personal service counted. Peter Vassallo fishmonger shop was next to W. J. Colwell's newsagents and sweet shop, then Mason's shoe bar, selling and repairing all manner of footwear. After that another butcher, H. Sharps, with Fine Fare stores next door to them. Allen's of Laygate had a branch selling the same fashionwear as their Laygate store, but by 1958 the store had been taken over by L & N Self Service Store. Self-service was quite a novelty at the time with customers able to pick which items they wanted without having to stand in a queue at the counter to be served, but queueing at the check-out instead.

Horsley Hill shops were built when the Marsden Estate began to spread. At first there was only Miss Jenny Hampton's House Shop, No. 2 Cheviot Road, which was a grocer and general dealer, selling everything you required from 2 ounces of butter, a stone of flour, tinned food, sweets, tobacco and cleaning products. The shop always looked cluttered as the shop counter was in the middle of what should have been the sitting room of the house. Flour and sugar were kept in big wooden bins in the kitchen along with scales for weighing the prepacked bags of flour and sugar. Bacon, cooked meats and butter were kept cool on marble slabs in the pantry. On one side of the counter was a large slicing machine for cutting bacon and cooked meats and a smaller set of scales for weighing the bacon, cooked meats and butter. Tins and other convenience foods were kept on shelves either side of the fireplace. Mr McLean, the butcher, had a wooden hut attached to the back part of the house with his meat hanging from hooks on a wooden frame. Mrs Juke's greengrocers' shop was at No. 4 Cheviot Road. When the shops were built Mr McLean and Mrs Jukes took two of the new shops. S. J. Harrison, better known as Sammy, was not only a stockist of cycles but also sold paint and household cleaning utensils; he also sold fireworks for bonfire night and a selection of toys at Christmas. Harry Hill, butchers, advertised the largest selection of fresh and cooked meats in the area. E. M. Moore sold fresh fish as well as fish and chips. G. H. Stamps, newsagent, confectioner, tobacconist and fancy goods

The Nook shopping area, as it is populaly known, stretches from King George Road to Centenary Avenue with a few shops in Sunderland Road.

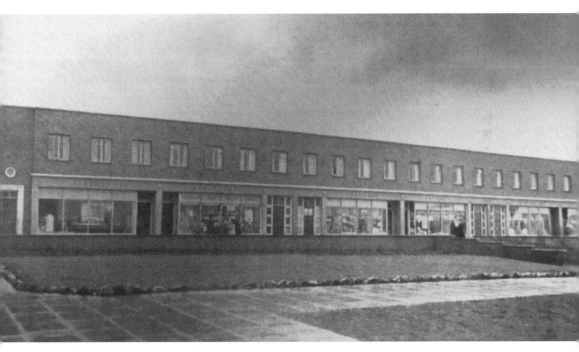

A row of shops at Horsley Hill.

shop was also the post office and if you posted a letter or card before 10 a.m. it would be delivered locally the same day. The chemist was next to Mr McLean's butcher's shop and then Joice's grocery and provisions shop with that personal touch.

In 1958 six more shops had been built at Horsley Hill, two of which, on the Marsden Road side, included the dairy and Loads' sweet shop, and four on the Centenary Avenue side included Rutter's butcher shop and another newsagent.

With plenty of shops to choose from nearby residents tended to shop on Westoe Road. Sharp's, boot and shoe retail and repair shop at No. 106 was before the bridge, with A. B. Robinson & Son, butchers, on the right-hand side; then J. Purvis' bakers and confectioners near Hyde Street, W. Bates shoe shop beside Wharton Street, Berryman's greengrocer with G. Dalfield's greengrocer almost opposite. The Bible shop was beside Elizabeth Street, with Harrold Potts' butcher's shop two doors away. George E. B. Grozier's heating, plumbing and gas-fitting shop was next to the Mineral Line. Grange laundry was the only laundry in town that picked up and delivered your laundry, which was popular with the working housewives as well as the more affluent ladies in the town. As mentioned the new Jarrow & Hebburn Co-operative Store had just opened. Although work had started in the late 1930s it was not completed until 1950. It was arranged over four floors, the ground floor taking up the drapery, haberdashery and men's shop. The first floor was gent's tailoring, mantles and millinery, fitting room and rest room; the second floor furniture and the top floor hardware and carpets.

On Charlotte Terrace, connecting Westoe Road with Fowler Street, Rippon's toy shop was one of the most popular shops selling all manner of toys – Tri-ang motorcars, tricycles, prams, bicycles, doll's houses, desks and chairs, 'Mobo' Broncos swings, merry-go-rounds and aeromodelling kits. A. M. Rogers, costumiers, also had a shop here and were renowned for their elegent dresses, wedding dresses with all manner of accessories for the bride, bridesmaids and wedding party. They also catered for the fuller figure.

In Fowler Street was Derek Thorpe's lighting centre, a beautiful shop displaying chandeliers, lamps and standing lamps, it was always an attraction. Frank Lake's ironmongers took up most of the next block selling everything from a single nail to cooking utensils and the latest electrical goods. There were Thompson Bros., radio dealers, Bond's fashions selling the new season's fashions by famous fashion houses, Jennie Peacock's milliners for the latest style in hats, Hinton's grocery store on the corner of Keppel Street and Glassburg ffurriers, for the finest fashions and beaver-lamb fur coats.

On the right side of Fowler Street was Victoria Hall with Ramsey's electrical store and the Victoria Dance Hall above, A. H. Cowey, radio engineer, selling the latest in radios and televisions, G. Arthur Brown, motor engineers, selling motorcycles as well as bicycles. Next door the house belonged to Dr Crisp, then Arthur L. Smith, dispensing chemist, came next, followed by Babyfair specialising in pram and nursery furniture, and on the corner Grantham's furniture store, Across the road was N. Goff tailors, Kay's Stores on the corner of Saville Street, W. Wheldon, clock and watchmakers. Ramshaw's seed shop, selling all manner of goods for the garden or allotment, was next door, then Tonneson's pork butcher, who in 1958 was taken over by Dickson's. Conway's

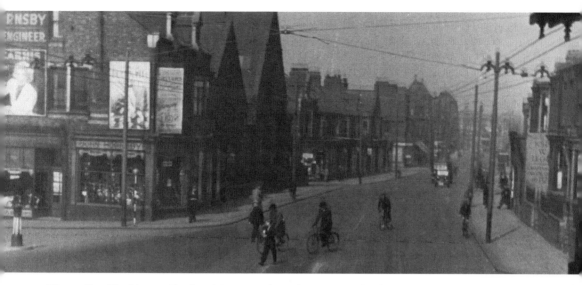

Westoe Road looking to Charlotte Terrace and Fowler Street, with John Hornsby's motor engineers and cycle shop on the corner of Victoria Road. (Photograph courtesy of South Shields Library)

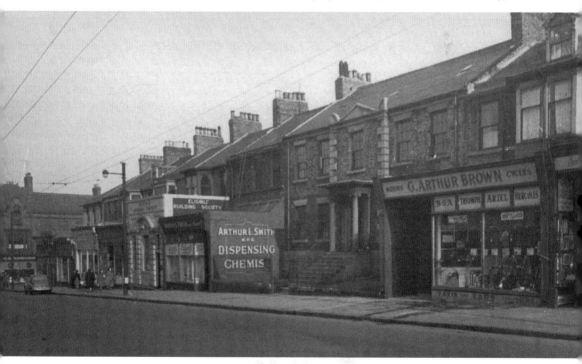

Fowler Street is a very busy thoroughfare. (Photograph courtesy of South Shields Library)

opticians was next with Rippon's sports centre, which not only sold sportswear but toys as well. Then J. J. Grant's silversmith and jewellers, and G. K. Lea's ladies' wear next door. With over 100 years of service it was one of those quaint shops with stairs and rooms on different levels. At the bottom D. Phillips, newsagent and bookseller, sold books on farming, gardening and cookery, and then Corner House, confectioners, with J. H. Oliver, the tobacconist and sweet shop, next to the Criterion Hotel.

Ocean Road was one of the town's most popular thoroughfares, full of shops with a wide range of goods to tempt the local population and the holidaymaker into spending their money. Wood's the tailors was the town's most popular tailor, selling all the naval cadets their uniforms, men's raincoats, rain-resistant cotton gabardines, riding macs, school wear for all ages, boys' and youths' two-piece suits, boys' jerkin suits, blazers, sports jackets and flannel trousers, school trench coats, gym tunics and blouses, ladies' slacks, skirts, blouses and twin sets, not forgetting their tailoring-to-measure service.

Minchella & Co., café and ice-cream shop, was always a favourite with the Marine College students who would go in for one cup of coffee and several straws. Their knickerbocker glory was a real treat with fruit, nuts and two scoops of different flavoured ice-cream and drizzled in syrup costing around 2/6d (just over 22p). Albert Mancini's was another favourite of the family, selling ice-cream and other confectionary delights.

Wigg's, famous for grand pianos, was the piano centre of the North selling all models of pianos including Bluthner, Bechstein and Steinway, as well upright and mini-pianos. Wigg's also sold records, radios and radiograms, cabinet, console table and miniature models.

Stitt's drug store was like an old-fashioned apothecary. People were not only able to get patent medicines but Mr Stitt, although not a fully qualified chemist, would give advice and kept his own specially concocted medicines with his own label 'Stitt' on them. Many local families came to rely on his tasty liquorice cough mixture which he knocked up for them. Mr Stitt also had an amateur photography club which he ran on a Saturday morning.

Smith's other store in Mile End Road was just across the road. An advert in 1950 for Smith's shows a dining room suit in figured oak with canopy or mirror back if desired, panel or open back chairs, cost from £35 or 7s (35p) a week, a Chesterfield suit in uncut moquette, velvet, cow hide or rexhide, cost from £28 or 6s (35p) a week. Hoover cylinder model vacuum with tools £13/2/6 (just over £13.12) or 3/6 (just over 16p) a week.

Geo. Coulthard, chemists, was next to the Royal Hotel with W. Train & Co., confectioners, next door. Alfred Barclay's butcher shop was near Cleveland Street and Scot & Sieber's pork butchers two doors away. Littles' fruit shop was on the next block and M. Town's drapery store was across the road. Hertrick pork butchers and G. R. Clark's grocers were near Morton Street.

On Saturdays King Street would be teeming with shoppers and the choice was phenomenal. Meeting friends on a Saturday to go shopping or to meet for afternoon tea in the delightful surroundings of Binns Café where the tables were elegently covered with white cloths and set with knives and forks were options. If you were lucky you might often hear a band play, or see a mannequin parade as staff modelled the new season dresses and coats. Then have a wander through their many delightful

The bottom of Fowler Street with Rippon's sports shop, Conway's opticians, Tonneson's pork butchers, Ramshaw's seed shop and the wall of St Thomas' church. (Photograph courtesy of South Shields Library)

Wood's, tailors and outfitters store in Ocean Road. The store is decorated for the coronation of Elizabeth II. (Photograph courtesy of South Shields Library)

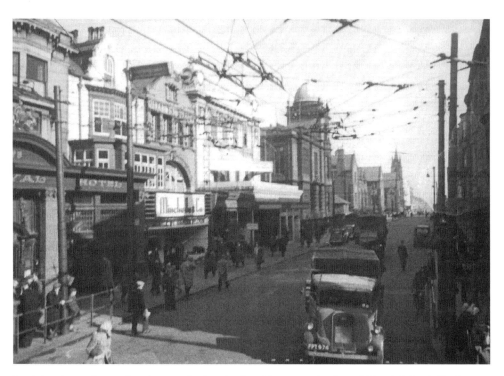

Looking down Ocean Road towards the pier head in 1950, the Royal Hotel, Minchella & Co., and Wiggs' piano shop to the left. (Photograph courtesy of South Shields Library)

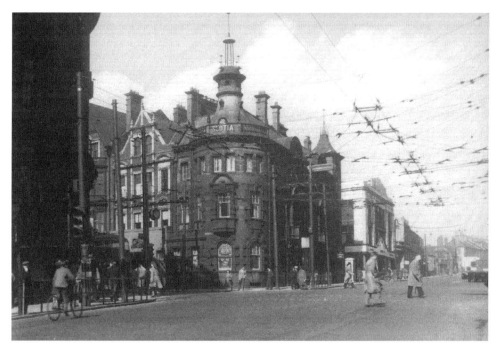

Looking up Mile End Road with the Scotia public house on the corner and Smiths Ltd, Moorgare House, one of their two Smith's furniture stores. (Photograph courtesy of South Shields Library)

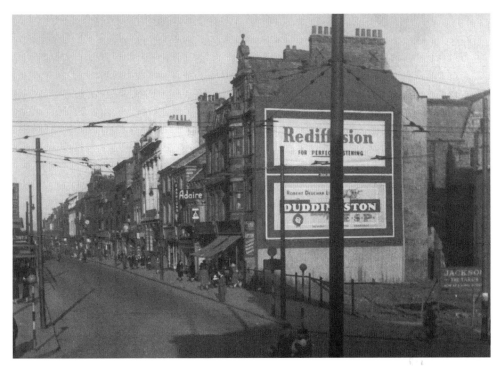

King Street 1950. On the left Woolworths still had the scaffolding up, and on the right an empty plot where Black's once stood. (Photograph courtesy of South Shields Library)

departments arranged over four floors, from the footwear department in the basement, the men's department, ladies' accessories, a big attraction on the ground floor, to the ladies' dress department for the latest fashions as well as beautiful underwear, and a record and gramophone department on the second floor. It also boasted a hairdresser on the third floor, which catered for both men and women. In the basement a subway led under East Street to the furniture store.

After being being destroyed by the bombing of 2 October 1941, Woolworths reopened at 9 a.m. on 11 August 1950 to the delight of the populace, with only the basement and the ground floor completed. The basement was a temporary stockroom, which was later used for sales, while the ground floor was the only sales floor; later this would be divided and part of the back was used as the stockroom. Many women had queued in their hunt for nylons. Most of the new interior looked bright and airy, and there was a friendly service from the staff.

Marks & Spencer, with their latest fashions, was another popular store. There was a great choice of fashionable footwear from Trueform Boot Co. Ltd, Timpson's, Riddick's, Harry Martin or Cable's all giving their own personal service. Alexander's, John Collier's, Crowell's, Dormand's and Jackson's the tailors were all outfitters. There were Halfords cycle dealers and Lloyds Ltd, and toy shop. J. J. Grant's silversmith and jewellers had in their attractive window displays beautiful crystal, plates, pewter, clocks and watches alongside a magnificent display of gold and silver jewellery.

There were also Hardy & Co. Ltd, and James Woodhouse & Sons, both furniture dealers, for the latest in furniture, pianos and bedding, where more expensive furniture could be paid for weekly; Mason's, chemist, also sold Australian wines full strength, Millar's British wines, green ginger, ginger, raisin, orange and blackcurrant, Tarragonas wines, Douro ports and clarets besides all manner of gifts and sweets; Hogg Bros selling all that a student required as well as artists' material; A. J. Ware's Ltd who sold all manner of goods, hardware, silverware, glass, travel goods, sports goods, sports trophies, fireplaces, sanitary fittings and tools and T. & G. Allan for fancy goods, handbags, leather goods and jewellery.

South Shields was granted a market in 1770 with the first weekly market being held on 17 October 1770 and a half-yearly fair from June 1771. With the market three times a week on Mondays, Fridays and Saturdays, it attracted more visitors to the town. Most of the market area had been destroyed in October 1941.

What was left of the marketplace in 1950 wasl very little still, but this did not deter people from coming to get a bargain or two from the stallholders who sold everything including clothing, fruit, vegetables and meat, even china and furniture. On Monday, Friday and Saturday you could always rely on a good crowd jostling their way around looking for a bargain. Fish fresh from the quay and fresh meat from the slaughter housewould be in great demand. Stall holders came from far and wide to sell their wares.

Although the market was badly damaged, you still had a number of shops in which to spend your money. Barbour's department store had its 90-foot frontage of modern window display showing attractive clothing for all the family and goods for the household. Behind the scenes were their workshop and mail-order goods department sending the clothes made in South Shields all over the world. Barbour's is still famous for its Beacon thorn-proof clothes, single-breasted coats, storm-front coats with sou'wester to match (extra) to two-piece suits ranging, at that time, from £5 to £8/12/6d (just over £8.62), sou'westers 12/6d (around 62p).

Chris B. Watson, on the corner of the marketplace and Church Row, was another store lucky to escape the bombing. It specialised in men's wear, selling the latest in menswear fashion from shirts and ties to Stormguard utility wool gabardine raincoats.

Looking up King Street towards Grant's Jewellers is Alexander and John Collier, both tailors, Halfords cycle and toy shop, Rapede Ltd., portraits and photography shop, and the arcade entrance to The Avenue Hotel. (Photograph courtesy of South Shields Library)

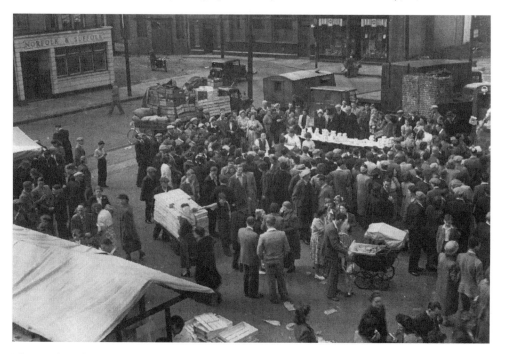

The Market Place in 1950 with J. D. Ainsley's, The Exchange Vaults and the Norfolk & Suffolk public houses left standing. (Photograph courtesy of South Shields Library)

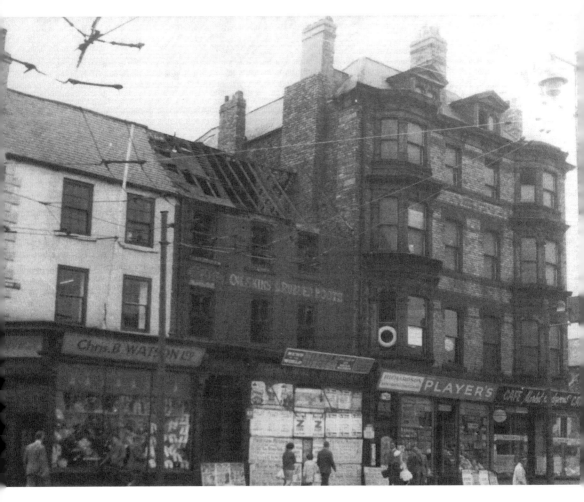

What was left of the south-western side of the marketplace was Chris. B. Watsons men's outfitters, the badly damaged Foreign Money Exchange, Richardson's newsagent and tobacconist shop and the Market Café. (Photograph courtesy of South Shields Library)

8

Transport – Getting Around

Recommendations that the trolleybus and motorbus network be expanded were made on 5 January 1948. The trolleybus network was to be extended from Horsley Hill back to the market via Horsley Hill Road; this service was extended to Marsden Inn and back to Horsley Hill, then to the market. On 28 March and on the 5 April a motorbus service was introduced linking Horsley Hill and Marsden with the Bede Trading Estate and a new service between the market and Horsley Hill via Sunderland Road was introduced on 12 July.

1 April 1950 saw the introduction of the busroute numbering system on both the trolleybus and motorbus services. At this time the trolleybus route took a wide variety of routes around the town. The number 1 bus ran from the market to the pier head while the no. 5 bus ran from The Lawe to the Ridgeway; the number 7 went from the market place via King Street, Fowler Street, Westoe Road to Westoe then along Sunderland Road, King George Road and then Prince Edward Road to the Nook, continuing to Centenary Avenue and Horsley Hill and back; the number 11 started from the market place, went via Station Road, Adelaide Street, Laygate, Mortimer Road, King George Road, Prince Edward Road to the Marsden Inn, down Marsden Road to Horsley Hill then along Cheviot Road, Highfield Road, Horsley Hill Road to Westoe then down Westoe Road and Fowler Street along King Street back to the market place and the reverse was the number 12.

The bell punch (better known as the mousetrap because of the way it snapped back so quickly that you could easily get your finger trapped in it) was replaced by Ultimate tickets.

By the 1950s the trolleybus service had reached its peak and by 1952, with falling passenger numbers and rising costs, both the trolleybus and motorbus services were reduced. However, by 20 September 1954, with the development of West Simonside and the Biddick Hall Estate, a full motorbus route had been established.

In 1953, to replace the passenger train service to Whitburn Colliery, a joint venture between the Northern General Transport and Economic bus service started a service between South Shields and the colliery, and in 1955 Northern General Transport in a joint service with South Shields Corporation to and from South Leam Estate and Brockley Whins.

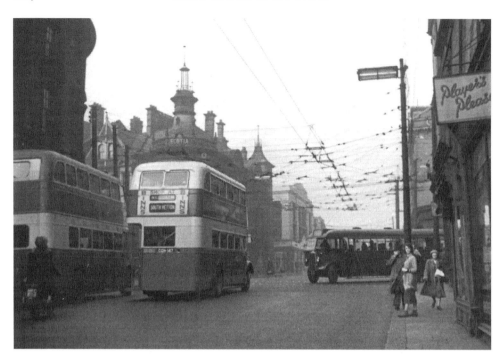

Looking towards Mile End Road, two motorbuses are waiting at the traffic lights, the one on the left waiting to turn into King Street, the one on the right waiting to go up Mile End road, while the Economic bus is turning into Fowler Street from Ocean Road. (Photograph courtesy of South Shields Library)

The number 12 trolley bus at the top of Marsden Lane on its way back to the Market via the Nook, King George Road and Laygate. (Photograph courtesy of South Shields Library)

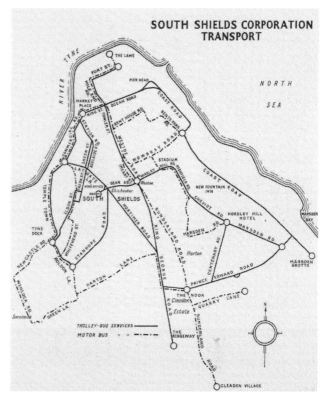

This map shows the many bus routes undertaken by South Shields buses in 1950.

The new Ultimate ticket machine introduced to replace the bell punch machines. This machine remained in use until 1983.

By 1956 there was a fleet of forty-one motorbuses and fifty-nine trolleybuses operating over 3,541,159 miles a year, over 47.52 route miles and carrying 42,890,047 passengers.

By the end of the 1950s the Economic bus service was running a circular bus route from Sunderland along the Coast Road to the pier head, Ocean Road, Fowler Street, Westoe, Sunderland Road, Marsden Road, Horsley Hill, Marsden Inn, The Grotto, then back to Sunderland and reverse. The Northern General Transport buses ran from Moon Street to several destinations including Sunderland, Newcastle, Washington, Chester-Le-Street, Esh Winning and Easington Lane. There were also two Northern bus services from Horsley Hill to Newcastle; the number 86 service went via Marsden Inn, the Nook, Prince Edward Road, Harton Lane, Simonside and the Scotch Estate to Newcastle Road and Newcastle while the number 87 service went via Marsden Inn, Prince Edward Road, Tyne Dock, Jarrow, Hebburn and Felling to Newcastle.

South Shields had four ferry services: the Steam Ferry Service, from Ferry Street; the Direct Ferry Service, from Kirton's Quay, Wapping Street; the Corporation Quay service near the Mill Dam and the River Tyne Commissioner's service known as the Whitehill Point Ferry.

The ferries *Northumbria* and *Tynemouth* became the means of transporting thousands of shipyard workers, holidaymakers, visitors and vehicles across the Tyne between North and South Shields throughout the 1950s. This was a regular fifteen-minute service crossing midway between the two ferry landings. These coal-fired ferries gained a reputation for their efficiency in all weathers; the smell of hot oil could always be smelt and the engine hatch was usually left open because of the heat down below and on those cold winter days many passengers would be vying for a place beside it to keep warm. Passengers could expect to pay sixpence (around 2p) but if you had a pram or bicycle you would pay 1/2d (7p). A passenger ferry service still runs between the two towns although it is now only a half-hourly passenger service.

In 1950 the town was connected to the rest of the country by the railway which ran to both Sunderland and Newcastle-upon-Tyne. From Newcastle you could get connections to all parts of Scotland, Wales and the ferry terminals of Liverpool, Stranraer, Hull and South Coast. In 1938 the London North Eastern Railway Co., as it became, electrified the Newcastle to South Shields railway line and in 1944 plans for a new station at the bottom of Victoria Road were scrapped. In 1949 the old bridge in King Street was replaced along with the wooden one in Queen Street. In the 1950 the railway brought many visitors to the town, some coming for the day to enjoy the beaches or the shops, while others would stay for a week's holiday or to visit friends and family. Trains to Newcastle would start at 4.55 a.m. and continue until 11.25 p.m., getting into Newcastle just after midnight to allow any late visitors to the town plenty of time to get transport home.

Not many people could afford to buy a car in the early 1950s; there were less than two million in the whole of Britain but as the decade progressed and people became more affluent the number of cars on the roads of South Shields increased tenfold and

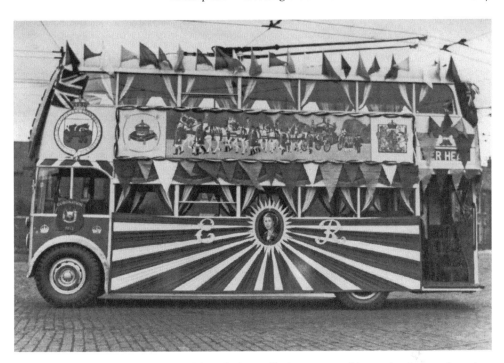

The Coronation Celebration Bus. Although this trolleybus was used in service, it was also taken out of service to be taken on a tour of the town for an hour and then returned. (Photograph courtesy of Beamish Open Air Museum)

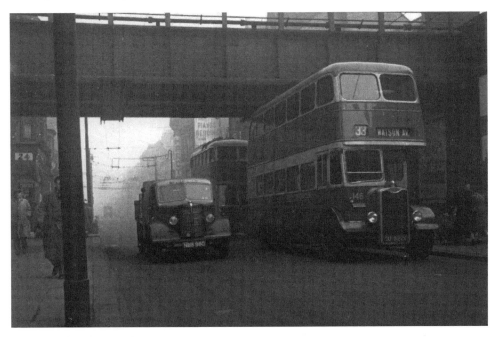

The 33 service to Watson Avenue went via Tyne Dock, Boldon Lane, Harton Lane, King George Road, The Nook and Sunderland Road, before turning along Quarry Lane to Watson Avenue. (Photograph courtesy of South Shields Library)

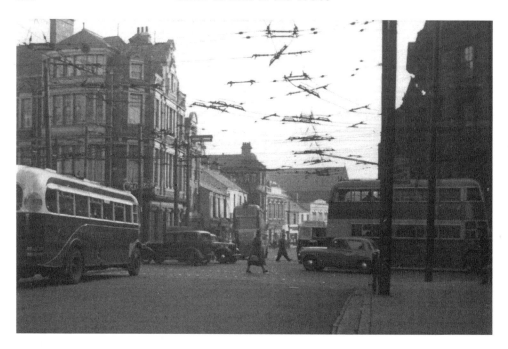

The junction of Mile End Road, Ocean Road, King Street and Fowler Street, buses, cars and pedestrians all trying to cross the junction at the same time. (Photograph courtesy of South Shields Library)

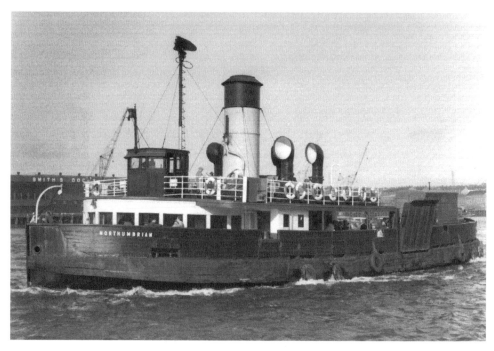

The ferry *Northumbrian*, bringing both foot and vehicle traffic from North Shields to the ferry landing at the bottom of Dean Street, off Ferry Street. (Photograph courtesy of Andrew Stenton)

The push and pull train that operated on the South Shields to Newcastle and the South Shields to Sunderland lines until they were replaced by the diesel multiple-units. (Photograph courtesy of South Shields Library)

many ordinary folk were able to afford a car. Cars like the Morris Minor, Austin A40, Ford Anglia and the Morris Oxford were becoming popular and the second-hand market in cars allowed the ordinary man in the street to become a car owner. Parking started to become a problem and with no official car parks people parked on the market square and anywhere it was convenient for them to park.

With cars becoming more popular, shoppers had to find places to park and River Drive was a good choice for its close proximity to the town centre shops and the market place. (Photograph courtesy of South Shields Library)

Glen Matthews was the first person in the street to own a car.

9

Played In South Shields

South Shields had many football teams in the 1950s, amateur and professional. Youth clubs, pubs and many companies supported the amateur teams who played mostly on a Sunday, hence the name Sunday League. Matches would be played on sports fields like the recreation ground at Cleadon, Horsley Hill, which was the Greyhound Stadium, or the Bents recreation ground on Sea Road. One of these teams was sponsored by George Lillycrop, manager of the Walpole Inn, Walpole Street, Laygate. Every year the team played a grand charity match against Harton Colliery Welfare on Good Friday at 10.30 a.m. in aid of Harton Colliery Miners' Christmas Fund. Many of the Lillycrop XI team in 1950 had been professionals at one time: A. McInroy (goalkeeper) had played for both Sunderland and Newcastle, gaining an FA Cup Medal in 1932; Warney Cresswell (left back) had played for South Shield, Sunderland and Everton, gaining a Cup Winners Medal in 1932/33 and capped for England; Corbet Cresswell (left back) captained Durham County Youth XI; H. Ellerby (right half) played for South Shields in their Second Division days; C. Hunter (centre half) played for Brentford; A. Andrews played for Sunderland and Blyth Spartans; W. G. Charlton (outside right) was better known as a Wearmouth and Durham County cricketer; C. Richardson (inside right) was a former South Shields favourite; H. Gallacher (centre forward), known as 'Wor Hughie' played for Newcastle, Chelsea, Derby, Notts. County, Grimsby Town and Gateshead, was capped for Scotland nineteen times; D. Parker (inside left) played for South Shields in the 1920s and T. Urwin (outside left) played for the big three, Newcastle, Sunderland and Middlesbrough, and was capped against Wales.

The Harton Colliery Welfare team comprised J. Lee, J. Simpson, J. Plank, W. Rowntree, E. Smith, W. Middleton, M. Coleman, A. Curtis, W. Mackey, T. Smith and J. Urwin. The referee was T. Greenhow (Sunderland) and the linesmen E. Irwin and G. Lillycrop.

These matches started just after the war and continued throughout the 1950s. The match in 1950 was won by Lillycrop XI 2-1. On that particular day South Shields also played West Stanley in the afternoon at 3.15 p.m. and on Easter Monday South Shields played Spennymoor at 3.15 p.m., both at Horsley Hill ground.

The town had eighteen teams that played in the Sunday Football league in 1956: Bents United, British Legion, Duncans, Greyhorse, Jarrow Chemical Works, Jacksons United, N.E.E.B., Press United, Prudasco, Rapide, Smiths United, Spartan, Simonside,

772

Grand Charity Match

GEORGE LILLYCROP'S XI
(WALPOLE)

versus

HARTON C. W.

at Horsley Hill on Good Friday, April 7th, 1950,

KICK-OFF 10-30 a.m.

"AH THOWT YE SED THE AALD 'UNS WAD BE
PLAYIN' ON CRUTCHES!"

ALL PROCEEDS IN AID OF HARTON AGED MINERS'
CHRISTMAS FUND.

Programme—THREEPENCE.

Shell Mex, Tyne Dock United, Vale United Wares and Westoe Villa. While most of the league clubs played on the Bents, the Greyhorse played on the Lighthouse field; Whitburn, Jarrow Chemical Works and Shell Mex played on Alkali field and Jarrow, the N.E.E.B, and Rapide played at Temple Park while Tyne Dock United and Westoe Villa played at Brinkburn. Each team supported their own colours and secretaries. The league president was Dr H. Byrne and vice-presidents were councillors J. Dixon, J. A. Clark and J.W. Ireland, and Mr H. Adair and Mr Thomas Cross.

South Shields Athletic Association Football Club was founded in 1897 and is credited with being the first football club bearing the town name. South Shields Football Club moved to their new ground at Simonside Hall in December 1950 after having problems at Horsley Hill with the Greyhound Stadium management and a bid to make themselves more independent with the help of a 13,000-strong supporter's club and the purchaser of the 15 acres of land, the club president and local auctioneer and valuator, Councillor Edmund Hill. Their first game was played in December and they decided to adopt the name 'Mariners'. Gradually Simonside Hall ground was developed and two grandstands, floodlights and a new social club was added with the hall itself providing offices, living accommodation, changing rooms and showers. With a strong supporter's club, the average home attendance was 7,000 but this was not enough to get them Football League membership and the 1950s saw the Mariners in five different leagues.

In, 1950 South Shields Cricket Club celebrated its centenary; it was started by a small group of enthusiastic sportsmen, with their first headquarters and ground on a field near the Lawe. The first recorded game was on 21 May 1850 against Tynemouth with a win for South Shields by 66 runs. Today boys start playing cricket in the junior school with school leagues in the fore and hard-won trophies take pride of place. In 1954 South Shields Cricket Club won the Durham Senior League under the captaincy of B. S. Land.

A large crowd turned out to watch the 1850s-style cricket match between the town council *and* N.A.L.G.O. in support of the centenary celebrations, with the proceeds going to the Mayoress' Charities Fund.

In 1950 tennis was not only played at Westoe Lawn Tennis Club but was played by most of the youth clubs and church clubs in the town with many of them having their own tennis courts in the church grounds. All the parks in the town had at least three tennis courts from which some of the clubs played their matches, and for sixpence (just over 2p) anyone could go along and play. Many a time you would need to book as the courts were very busy.

South Shields Harriers is one of the oldest sports clubs in the town. After the Second World War the ladies continued their success while men like Jock Biggs, Ralph Sheraton and Dave Deacon furthered their North-East success while Joe Relph took up coaching after his running career finished. The Harriers always tried to promote athletics in the town; for over forty years J. G. McFarlane organised the Ingham Infirmary Sports, attracting leading international runners.

On Wednesday 5 July 1950 the Ingham Infirmary and the hospital held their annual sports at Westoe Cricket Ground, Woods Terrace at 6 o'clock, in aid of the Ingham

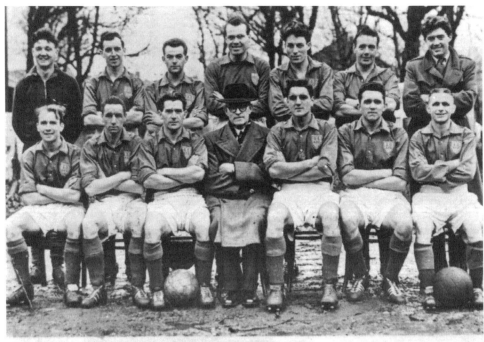

SOUTH SHIELDS A.F.C. 1957-8

South Shields football team of the 1957/58 season. Unfortunately there are no names with the photograph. (Photograph courtesy of South Shields Library)

1958 was the Golden Jubilee for the Schools' Football Association and at that time the town had no fewer than twenty-seven schools playing in the league. Many of the ex-players had gone on to become international players and schoolboy international players.

Dressed as cricketers of 100 years ago, the town council cricket team, Toppers, celebrates the club's centenary.

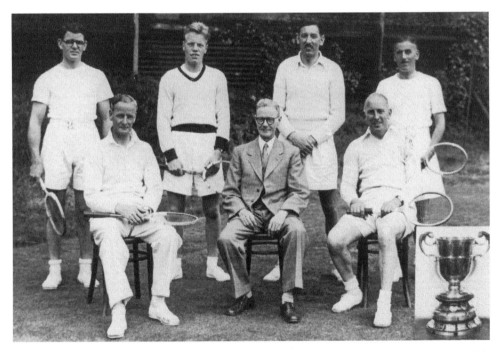

In 1951 Westoe Lawn Tennis Club won the Northumberland and Durham Counties Inter-club League. Back row: E. Scanlon, H. Conway, A. Morton, S. Routledge. Front row: A. Aitchison, G. Aitchison (Captain), and R. L. Young. (Photograph courtesy of South Shields Library)

Infirmary, with stars such as the Olympic runners McDonald Bailey and Arthur Wint included in the record entry. Results:

- One-mile flat handicap – R. W. Poxon (Bedlington)
- 880 yards invitation race – Arthur Wint, Olympic champion
- 100 yards youth handicap – L. Walker (Middlesbrough)
- Women's relay – South Shields

South Shields Cricket Club, Amateur Athletic and Cycling Sports had a record crowd as over 6,000 turned out to watch the programme at Westoe Cricket Ground for the club's centenary sports event which also took place in 1950. Len Eyre, the Empire three-mile champion, competed in an invitation mile race, giving the best locals, including Frank Sinclair, a 30-yard start. Len Eyre won the race in 4 minutes 15 seconds, the fastest mile yet. Hull ladies and eight local clubs were all competing for to be first holders of the South Shields County Borough Centenary Challenge Cup for the 4 x 110-yard relay race. Hull Women's Athletic Club won in 53.2 seconds, beating all their rivals.

South Shields Chess Club held its first chess night in October 1866 at the Mechanics' Institute, later South Shields Library. In 1944 the club was reformed and in February 1947 Mr Arnold L. Friends, the club president, presented the club with a trophy for members to win when playing chess within the club. Competition was fierce but all members had an equal chance of winning. Mr L. Pickersgill won the trophy in both 1951 and 1952 while T. P. Jones won the trophy in 1950 and 1954; Mr L. Oliver won the trophy in 1955 and 1956 and at that time the venue was Mortimer Road School.

First lap in the youths' 880 yards title race in the Ingham Infirmary and Hospital's Annual Sports at Westoe Cricket Ground.

The Friends Bowl, presented to the South Shields Chess Club by Mr Arnold L. Friends in February 1947, is still played for today. (Photograph courtesy of Eddie Czestochowski)

Acknowledgements

I would like to thank Catrin Galt of South Tyneside Library for permission to use the photographs from the collections of Amy Flagg, George Wanless, F. Mudditt, Dixon and the unknown photographers who have donated their collections to the library. Thanks to Margaret Hamilton and Pauline Shawyer for their kindness and encouragement, and helping me access a number of photographs for this book. I would also like to thank Adam Bell of South Shields Museum & Art Gallery for giving me free access to their archives, which were invaluable in helping me with my research, Julian Harrop of Beamish Open Air Museum for giving me permission to use the photographs from their collection, Andrew Stenton for photographs belonging to his late grandfather, Eddie Czestochowski and Pat Stevenson for sharing their photographs, Eddie McCann, Billy and Peggy Murtaugh for sharing their reminiscences of the 1950s, *South Shields Gazette*, June Gowland for permission to relate the story about her father's shop and Glen Matthews, Phillip Lambart and Margaret Lynch. Finally I would like to thank Pam McTaggart for the proof-reading and my husband Colin for his patience over the last few months that I have spent researching this book.